IMAGES
of America

CAMBODIANS
IN LONG BEACH

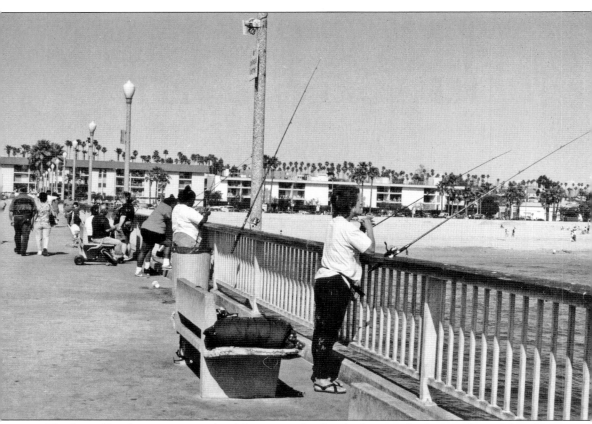

The Long Beach pier is a popular fishing spot for Cambodians and other residents. The close proximity to the ocean and being able to fish like they once did in Cambodia made Long Beach an attractive place to live for Cambodians. (Courtesy of Kayte Deioma Photography.)

ON THE COVER: Students at Wilson High School perform the Coconut Dance in 1994. (Courtesy of Sithea San.)

IMAGES
of America

CAMBODIANS
IN LONG BEACH

Susan Needham and Karen Quintiliani

ARCADIA
PUBLISHING

Published by Arcadia Publishing
Charleston SC, Chicago IL, Portsmouth NH, San Francisco CA

Printed in the United States of America

Library of Congress Catalog Card Number: 2007937762

For all general information contact Arcadia Publishing at:
Telephone 843-853-2070
Fax 843-853-0044
E-mail sales@arcadiapublishing.com
For customer service and orders:
Toll-Free 1-888-313-2665

Visit us on the Internet at www.arcadiapublishing.com

*We wish to dedicate this book to
the Cambodians of Long Beach, California.*

CONTENTS

ACKNOWLEDGMENTS

We are grateful to everyone who took time to share their photographs and life stories with us. We appreciate your wisdom and unending patience in answering our questions. Hundreds of people contributed photographs and important historical context about groups or events for this book project, far too many to acknowledge here. We would like to thank the following individuals, organizations, and groups: Aumry Ban; Bryant Sokphanarith Ben; Mary Blatz, Mount Carmel Cambodian Center; David Board, Pacific Baptist Church; Gareth Bogdanoff; Master Ho and Sokhanarith Chan; Michael Burr; Pasin and Rosana Chanou; Kung Chap and Sophalla El Chap; Sunthary Del Castillo; Elizabeth Chey; Pheany Richard Chey; Him Chhim; A. Brent Cobb; Rothary Dimang; Rev. Joe Ginder, Long Beach Friends Church; Leng Hang; Krithny Horn; Soben Huon; Praseuth and Sinane Hou; Fany Khiev; Yanna Keam; David Kreng; Kimthai R. Kuoch; Fred and Somany Lytle; Kayte Deioma; Dr. Kosal Kom; Thongsy Khuon; Rev. Chandara Lee, First Lutheran Church, Long Beach; Harrison Lee; Lillian Lew; Peter Long; Huot and Huoy Lor; Bonnie Lowenthal; Kim Ly; PraCh Ly; Rev. Sambath Mao, Cambodian First Baptist Church; Steve and Marcela Meckna; Kolvady Men; Men Riem; Rev. Anong Nhim, Long Beach New Life Church of the Nazarene; Chantara Nop; Baley Norodom; Dr. Leakhena Nou; Rev. Santhony Nou, Long Beach Cambodian Evangelical Church; Thommy Nou; Poe and Molly Ouklore; Sophea Pel; Dale Pettit and Sandy Escondon, the Church of Jesus Christ of Latter-day Saints; David and Vilay Poeung; June Ellen Pulcini; Phorn Chann; Se and Setha Phang; Navy Phim; Yon Pich; Sar Poeu; Savorn Pouv; Sereivuth Prak; Sokneath Prak; Phirum Sea; Seng Kheng; Richer and Sithea San; John and Sophiline Shapiro; Michael Sieu; Mony Sing; Thira Srey; That Sareth; Saren Sok; Lu Lay Sreng; Kenny M. Taing; Kiry Tam; Dr. Terpsie Kapiniaris-Tan and Dr. Song Tan; Bunsorng Tay; Seang and Bellavie Tea; Ngao Tou; Phylypo Tum; Rina Uch; Danny Vong; Wayne Wright, and Frank You (also known as Chhan Chhour).

We are grateful to the following temples that provided photographs and histories about their activities: Wat Bothiprikrattanaram, Wat Chansisothavas Kaub, Wat Khemara Buddhikaram, Wat Monyrangsey, Wat Samaki Dhammaram, Wat Sonsam Kusal, and Wat Vipassanaram. We would also like to thank these community organizations and groups that provided important information about their activities over the years: Cambodian Association of America; Cambodian Chamber of Commerce; Cambodian Coordinating Council; Cambodia Town, Inc.; Cambodian Student Society, California State University, Long Beach; Cambodian Veterans Association; Long Beach Nagas Dragon Boat Team; EM3; Families in Good Health (formerly Southeast Asian Health Project); Khmer-American Council; Khmer Girls in Action, and United Cambodian Community, Inc.

We would like to thank our Arcadia editor, Jerry Roberts, for guiding us through this very enriching process of producing a history of Cambodians in Long Beach. He was incredible until the end, exercising tremendous patience and understanding.

A special thank you goes out to those who helped us scan: Sarah Coté; Christie D'Anna; Robert Freligh, CSULB Audio Visual Services; Lilly Gonzalez; Rayed Khedher; Lisa Kidd; and Jeff Lewis.

Finally, we thank our families for the love and support they provide everyday so we can do the work we believe in.

The authors cited the donors of specific photographs when credit was requested.

All proceeds from book sales will go to the development of a virtual archive dedicated to Cambodian community history and to fund Cambodian student research.

INTRODUCTION

Long Beach, California, is home to the largest population of Cambodians outside of Southeast Asia. They have established a strong presence in the city of Long Beach in a relatively short period of time and built a vibrant and dynamic community offering goods and services to Cambodians and mainstream Americans alike.

Cambodians are a relatively recent immigrant group in America's history, and their story is very different from immigrants who came to this country before them. While most new immigrants can count on well-established communities to provide both emotional and economic support while adjusting to American life, Cambodians had no such luxury. Only a handful of Cambodians lived in the United States prior to 1975, and although they immediately extended help to those arriving in the early days, the essential networks and bridges to mainstream American life, jobs, and language would have to be created.

Cambodians also came to the United States as refugees. This means they fled their homeland out of fear without much prior planning and with nothing except the clothes they were wearing. The migration of Cambodians to the United States occurred in two main groups: those who were evacuated in April 1975 as the Khmer Rouge took control of the country, and those who came after 1980 following the invasion of Cambodia by the Vietnamese. Cambodians arriving in 1980 suffered physical and psychological trauma as a result of inhumane treatment at the hands of the Khmer Rouge. Practically every person arriving at that time had lost at least one family member to death by starvation, disease, or murder. Many had witnessed the deaths of siblings, parents, grandparents, and children and were helpless to do anything to prevent it. Escaping first to refugee camps along the border in Thailand, Cambodians were anxious to get anywhere they would find food, shelter, and some peace. Migration to America provided hope, and life in America demanded further sacrifices and determination. Many of the Cambodians who arrived in 1975 settled in the Long Beach area. There they formed organizations and programs first to help each other as they adjusted to American society and then to help their families and friends arriving after 1980. Although the U.S. Office of Refugee Resettlement attempted to encourage later arriving refugees to settle in other areas of the country, most were drawn to Long Beach by family and friends, jobs, the coastal climate, and access to the Port of Long Beach's Asian imports.

In only 30 years, Cambodians have accomplished much. They have participated in American politics on the local and national levels, they have built local and international businesses, they have created new art forms, and they have raised a new generation of Americans who promise to contribute to their adopted country's future and growth. The Cambodians have had an impressive and positive impact on the city of Long Beach and its citizens. On July 3, 2007, the Long Beach City Council formally recognized a section of Anaheim Street as "Cambodia Town," the first ethnic designation in the city's history and the first Cambodia Town in the nation.

The importance of this community as a Cambodian home extends well beyond Southern California. As Borann Heam, a Cambodian transplant from New York notes,

> We would like to think this is home. This is the largest [Cambodian community]. This is something you can be proud of. . . . Whether you're in New York or Boston, you want to feel proud about Long Beach because you want that big community to reflect you too."

The photographs and chapters that follow offer a glimpse into the lives and accomplishments of the Cambodians who have made Long Beach their home. Their pride in their community's accomplishments is well earned.

AUTHORS' NOTE: As you read the text of the book, you will notice two terms used interchangeably—Khmer and Cambodian—to name organizations, to discuss historical events, and to describe the culture. To better understand the usage of these terms, we briefly describe their meaning and historical context here.

The Khmer (pronounced *khmae*—the final "r" is silent) are the ethnic majority in Cambodia. The term Khmer refers to the people, their language (*piasaa* Khmer) and their country (*srok* Khmer). "Cambodia" is the English pronunciation of the French "Cambodge," which was derived from the formal Khmer name of the country, "Kampuchea." As in all modern nation-states, Cambodia is home to a mix of ethnic groups and those with mixed ethnicity, including Chinese, French, Lao Thai, and Vietnamese. Because this mix is reflected in the population of Long Beach and because most Americans are familiar with this name, we use Cambodian to identify all nationals originating from Cambodia and use Khmer to refer to aspects of the language and culture as appropriate.

One

EARLY CONNECTIONS
TO LONG BEACH

During the 1950s, 1960s, and early 1970s, Cambodia sent its brightest young men and women to universities throughout Europe, Asia, and North America. Several attended the University of Southern California, the University of California, Los Angeles, and the California State Universities in Los Angeles and Long Beach. Most students returned home to Cambodia after graduation, eager to develop their country's rich natural resources. Only a few students settled permanently in Southern California. Those who stayed and the few who returned to the United States before Cambodia fell to the Khmer Rouge would prove critical to the formation of the Long Beach community beginning in 1975.

The photographs in this chapter provide some background on the more significant symbols of Cambodian history and culture, as well as a glimpse into the lives of the students who made the first connections to Long Beach. Photographs of Cambodia and Cambodian students prior to 1975 are rare. During the Khmer Rouge, the educated and middle and upper classes were targeted for torture and murder. To protect themselves and their families, Cambodians made sure all evidence of an education or contact with Western countries was destroyed or hidden. Much was lost in the deadly turmoil and confusion of that time.

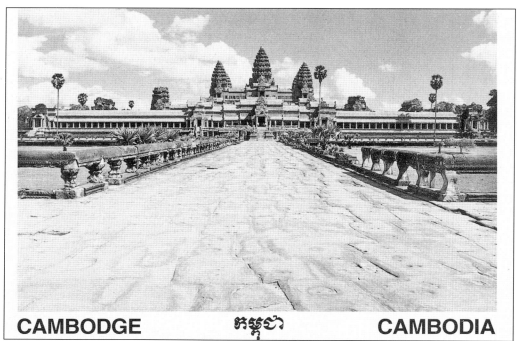

CAMBODGE កម្ពុជា **CAMBODIA**

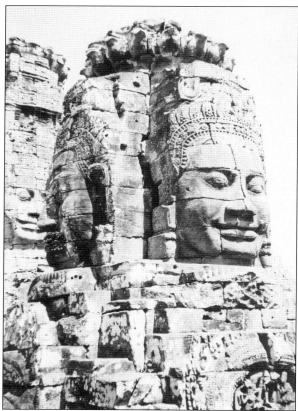

Angkor Wat, which means *temple city*, is one of the most well-known and beloved symbols of Cambodian culture and achievement. Its image is seen throughout the community on storefronts, in people's homes, and even on letterhead. The temple was built at the height of the Khmer Empire in the 12th century by Suryavarman II and was dedicated to the Hindu god Vishnu.

Another Khmer temple seen throughout the community is Bayon, built by the Buddhist king Jayavarman VII in the 13th century. During his reign, the Khmer Empire reached its greatest extent and included most of modern-day Thailand, Laos, and South Vietnam.

Temples built during the Khmer Empire were faced with sandstone upon which were carved thousands of images of Apsaras, *celestial dancers.* According to a 10th century Khmer inscription, the solar line of Khmer kings were descended from the wise man Kambu and his wife, Mera, an Apsara given to Kambu by the god Shiva. The story and the dance forms developed from the story reinforce the importance of women and the feminine aspects of Khmer history and culture.

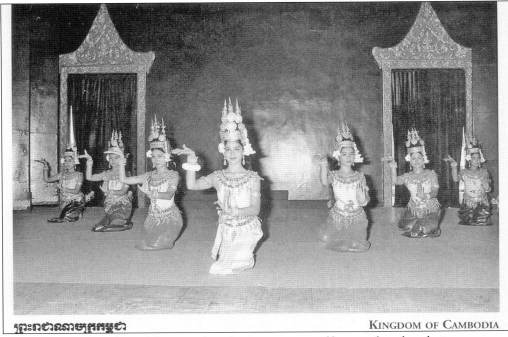

ព្រះរាជាណាចក្រកម្ពុជា KINGDOM OF CAMBODIA

Modern Cambodian classical dance, such as the Apsaras pictured here, are based on the images carved on the temple walls. Classical dance is an important art form in the Long Beach community.

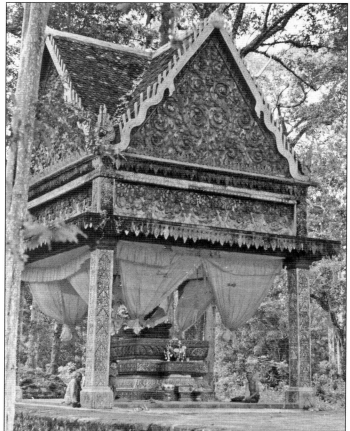

The majority of Cambodians are Theravada Buddhist. The establishment of Buddhist temples was among the first things Cambodians did after arriving in the United States in 1975 and was one of the reasons so many Cambodians came to Long Beach in the early days. (Courtesy of Bonnie Lowenthal.)

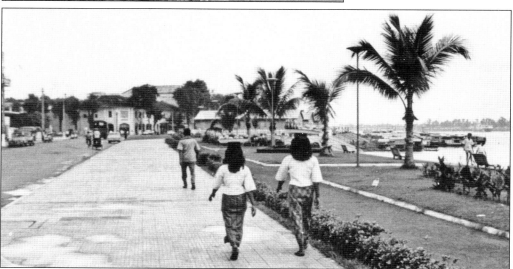

Phnom Penh, the capital city of Cambodia, was held by many to be the "jewel of Southeast Asia" in the mid-1900s. Rich in both natural and human resources, Cambodia had a bright future. This is the walkway along the Tonle Sap River in 1963. (Courtesy of June Ellen Pulcini.)

Leaving to study abroad was a momentous occasion. When Kheng Try Seng (center) left for California Polytechnic State University, San Luis Obispo, in 1962, his extended family came to see him off.

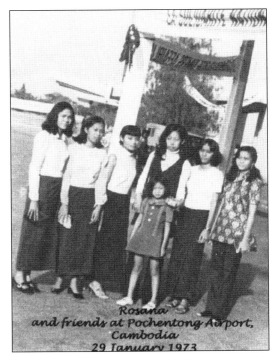

Rosana Chanou (center, behind the young girl) was seen off by her friends as she departed for Montgomery College in Maryland on January 29, 1973.

The **CAMBODIAN**

STUDENTS

in **U S A**

Present to you

The **"KSA YEARBOOK"**

The "Things done and observed

during our lifetime as students

abroad "

. . . As our paths, parted from our homeland

Came to meet, cross, hear and see

Things in the new world .

Cambodian students were spread thin across the United States. A feeling of loneliness led to the formation of the first Khmer Student Association in the United States in 1959. According to the 1962 *Yearbook of Cambodian Students in the USA*, the association's goal was "to aid other Cambodian students coming to the United States to adjust to their new environment, to establish and maintain solidarity among Cambodian students away from home, and to promote international understanding as well as greater knowledge of Cambodia." The yearbook included photographs of student activities across the United States as well as short articles in Khmer and English. (*Yearbook of Cambodian Students in the USA*, 1962.)

COLLEGES and UNIVERSITIES

ARIZONA		FLORIDA	
University of Arizona	Tucson	University of Florida	Gainesville
ARKANSAS		ILLINOIS	
University of Arkansas	Fayetteville	University of Illinois	Urbana
CALIFORNIA		INDIANA	
California State Polytechnic		Earlham College	Richmond
College	San Luis Obispo	Indiana University	Bloomington, Indianapolis
Fresno State College	Fresno		
Long Beach State College	Long Beach	IOWA	
Los Angeles State College of		Iowa State University	Ames
Applied Arts and Sciences	Los Angeles		
University of California	Berkeley	KANSAS	
COLORADO		Kansas State University	Manhattan
Colorado State University	Fort Collins	Kansas State Teachers College	Emporia
University of Denver	Denver	University of Kansas	Lawrence
CONNECTICUT		MAINE	
University of Connecticut	Storrs	University of Maine	Orono
DISTRICT OF COLUMBIA		MISSOURI	
American University	Washington	University of Missouri	Columbia, Rolla
George Washington University	Washington		

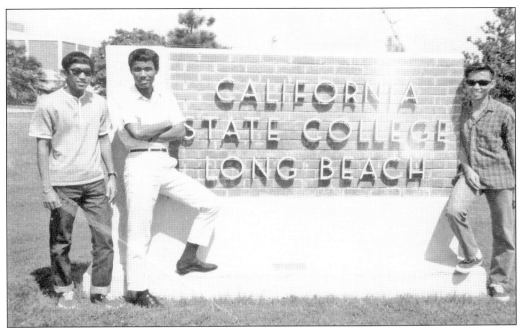

California State University, Long Beach, (CSULB) students (from left to right) Mamith Thong, Pheany Richard Chey, and Kheng Lay are pictured sometime between 1962 and 1964.

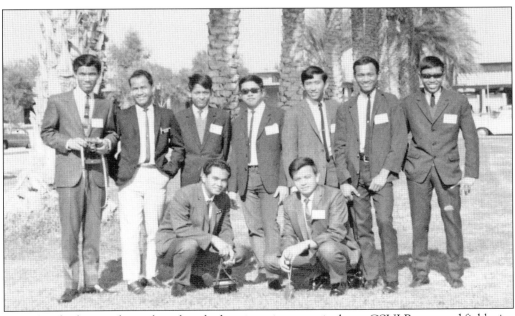

Most Cambodian students abroad studied engineering or agriculture. CSULB arranged field trips to enhance their educational experience. This photograph of the 1962–1967 class of Cambodian students was taken in Palm Springs at a date festival. From left to right are (first row) unidentified and Sareth Ek; (second row) Pheany Chey, Chan Hang, On Chak, unidentified, Mamith Thong, Chhorn Sam, and Bunhan Ker.

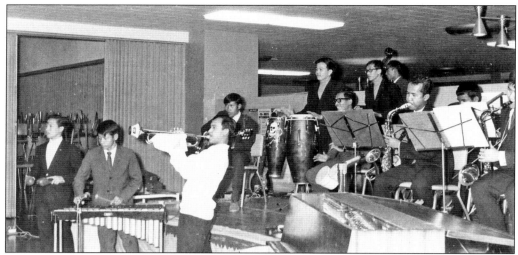

Even though most of them did not know how to play a musical instrument before coming to the United States, the CSULB Cambodian students decided to form a band as an activity they could do as a group. Many of them took private lessons and practiced on their own time. Before long, they became good enough to play at campus events and at Cambodian New Year. Sam Ol Prum, shown playing the trumpet, was the bandleader.

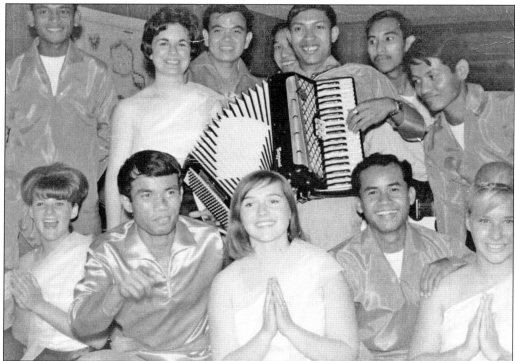

Although Cambodian women were also studying at universities in the United States, none attended CSULB at this time, so the young men taught other students Cambodian dances. The dance group is pictured here wearing costumes the Cambodian students made for a Cambodian New Year event c. April 1964.

Two

YEARS OF TURMOIL AND PAIN

Cambodians were forever changed by the brutal takeover of their country by the Khmer Rouge on April 17, 1975. The Khmer Rouge forces, led by the notorious Pol Pot, attempted to take Cambodia back to the glory days of the Khmer Empire in the 12th century. To accomplish their maniacal objective, they systematically cleared the cities and murdered the most educated members of society. Once forced into the countryside, Cambodians lived in abysmal conditions, lacking adequate food and health care, and were compelled to work in segregated camps for fear of beatings. By the time the Vietnamese invaded Cambodia and brought an end to Khmer Rouge control over the country in 1979, nearly two million Cambodians had died. The turmoil and pain did not end, however, in 1979. Cambodians, fearing more persecution, starving to death, and running from an advancing army, fled to the Thai-Cambodia border where refugee camps established earlier began to overflow. Once in the camps, they faced an uncertain future. Every Cambodian who survived the "Pol Pot time," as it is often called by community members, lost family members and friends or had been separated from close kin. The arduous process of rebuilding lives and reconstructing cultural traditions began in the camps. The only hope Cambodians had would be to be chosen for resettlement in France, Canada, Australia, or the United States, the main countries accepting Southeast Asian refugees.

This chapter depicts these years of turmoil and pain primarily from the perspective of the Cambodians already in Long Beach: their pleas for help to government officials, their protests demanding world action on behalf of their countrymen, and their material and emotional support of the first evacuees at Camp Pendleton and the refugees who came later. The survivors of the Pol Pot time are pieced together through the photographs of those who resettled in the Long Beach area and rebuilt their lives and a community. Many individuals and groups compassionately built the organizational foundation that led to Long Beach becoming the Cambodian capital of the United States.

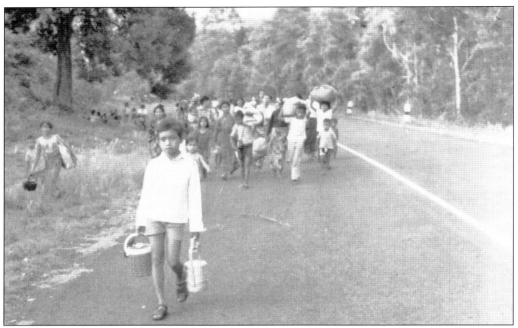

This rare photograph shows two groups of people fleeing across the Cambodian border into Thailand on April 11, 1975, six days before Cambodia fell to the Khmer Rouge. (Courtesy of Se and Setha Phang.)

An artist's drawing of the evacuation of Phnom Penh, the capital city, appeared in the Cambodian newspaper, *Nokor Thom*, on June 15, 1984.

The Khmer Solidarity Association of America, a group composed of Cambodian professionals, sent this mailgram on May 6, 1975, to Pres. Gerald Ford just a few weeks after the Khmer Rouge takeover of Cambodia.

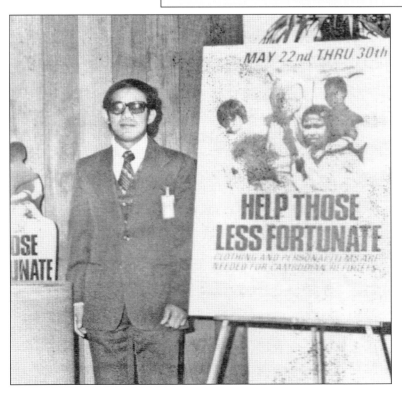

David Viradet Kreng, a student from the 1950s who went to work for Bechtel in 1968 and settled in Southern California, was instrumental in organizing assistance for the Cambodian evacuees arriving in Camp Pendleton in 1975. This photograph, which appeared in the *Bechtel News Southern California* in June 1975, shows Kreng standing next to a poster asking for donations of clothing and other personal items for the evacuees.

19

KHMER SOLIDARITY OF AMERICA
(CAMBODIAN ASSOCIATION)

1214 TERMINO AVENUE
LONG BEACH, CALIFORNIA 90804

(213) 434-5911

June 18, 1975

American Red Cross
Camp San Onofre
Pendleton, California

Gentlemen:

We are writing you with the request that you help us obtain passes to Camp San Onofre, Pendleton.

As representatives of the KHMER SOLIDARITY OF AMERICA, we have been for some time and still are conducting orientation meetings, interviews, consultation sessions within Camp San Onofre for the benefit of our Cambodian countrymen. The latter, as you know, feel much disorientation, confusion and frustration as they find themselves homeless refugees in a new land. Our contacts with these people, either in groups or on an individual basis, are aimed at alleviating the hardships they encounter as they are in the process of adjusting to the new situation and unfamiliar environment.

The new visiting hours, from 8 a.m. to 6 p.m., regulation restricts our activities to a great extent and we will not be able to accomplish much of our goals without a certain freedom of movement being made available to us within the camp.

Due to this inconvenience, we feel we are denied the privilege to do our job for our countrymen. We are a group of Cambodians who volunteer our time and efforts in order to help provide whatever support we can to the Cambodian refugees unfortunate enough to have lost most of everything except life. In this endeavor, we deserve a measure which would facilitate our activities, specifically a greater freedom to come and go within the camp.

We would appreciate your intervening on our behalf in this matter. We do not antici-pate resistance on the part of the authority involved with dispensing these passes as we are sure they will understand our problem once they are made aware of it.

Sincerely,

KHMER SOLIDARITY OF AMERICA

Paline Soth Viradet S. Kreng
Secretary President

Entero Chey Chhoeun Kem
Liaison Vice President

:STK

In this letter, the Khmer Solidarity Association Board of Directors appeals to the American Red Cross to extend the visitation hours at Camp San Onofre, a section of Camp Pendleton designated for Cambodian evacuees. The group was instrumental in providing material and emotional support to fellow Cambodians. The Khmer Solidarity Association later became the Cambodian Association of America.

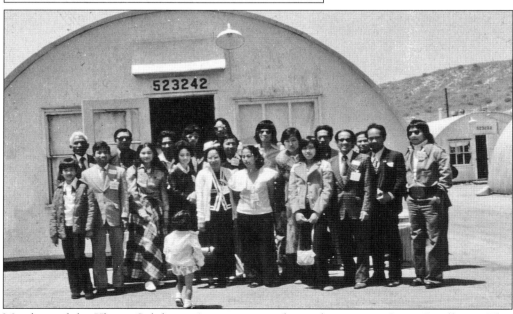

Members of the Khmer Solidarity Association made regular visits to Camp Pendleton. This photograph from May 1975 shows many of the members who formed the foundation for the Long Beach Cambodian community.

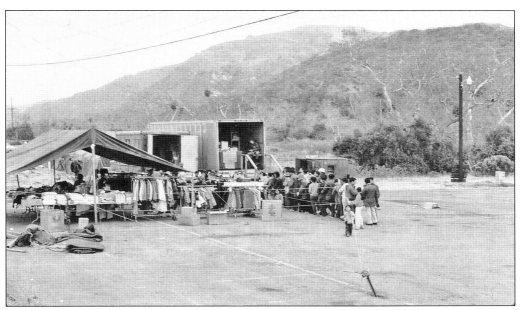

Cambodians arrived at Camp Pendleton with nothing except the clothes they were wearing. Clothing and other personal items were donated and made available to the evacuees.

Marines at Camp Pendleton often gave their military jackets to the refugees. After leaving the tropical heat of Southeast Asia, many felt cold living in the San Diego area. This picture shows a group of unidentified children at Camp Pendleton wearing military jackets given to them by marines.

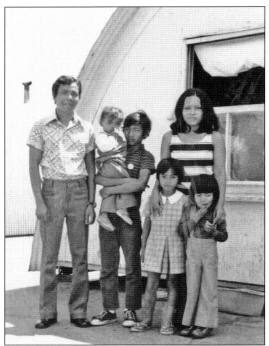

Kung Chap took this picture of his family and a friend, Be Keth (the man standing on the left), in front of the quonset hut they lived in while at Camp Pendleton in 1975. Chap's wife, Sophalla, is on the right with her arms around their oldest daughter, Sakada, and son Sokona; their adopted son, Sokunthea, is holding baby Dalia.

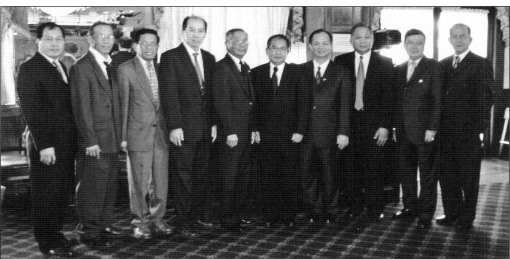

The Cambodian Veterans Association (CVA) was established on June 20, 1975, to provide services to refugees at Camp Pendleton and at other military bases in the United States where Cambodians were evacuated. Some of these early evacuees were military personnel stationed in Cambodia and other parts of the world. Over the years, the group has addressed the needs of veterans and provided leadership to Cambodian community organizations. Pictured are the CVA's executive board of directors and advisors from 2004 to 2007: (from left to right) Lim Hun Ty, air force, vice president; Chheang Sreng Sam, air force, director; Saphan San, army, vice president; Harrison (Bunny) Lee, air force, president; Hak Um, army, director; Vandy Khuon, navy, director; Chin Leng Kuoch, navy, director; Thong Sy Khuon, air force, advisor; Sareth Tath, army, director; and Morlandhy Kem, army, advisor. (Courtesy of the Cambodian Veterans Association.)

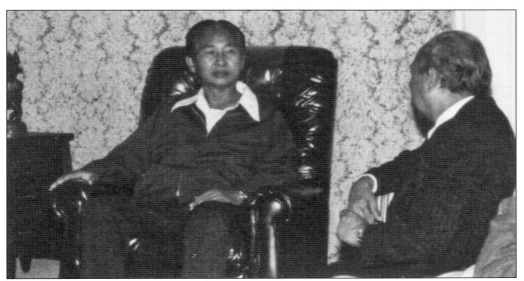

Marshal Lon Nol was president of the Khmer Republic until the Khmer Rouge took over Cambodia in 1975, and he was forced to flee the country. He eventually settled with his family in Fullerton, a city in nearby Orange County, a city bordering Long Beach. Lon Nol (left) speaks with In Tam, a former member of the High Political Council and prime minister of the exceptional government, in the early 1980s.

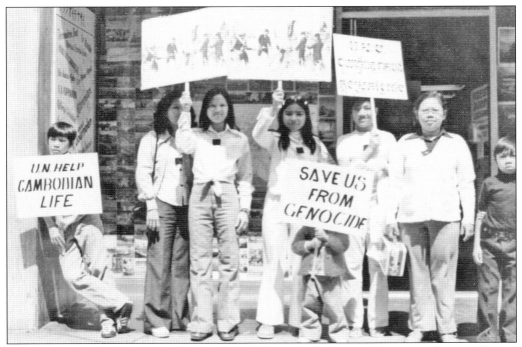

As reports from survivors of the Khmer Rouge atrocities leaked out to reporters and were published in the *New York Times* in July 1975, Cambodians from Long Beach and the surrounding area organized a protest in front of the United Nations building in downtown Los Angeles.

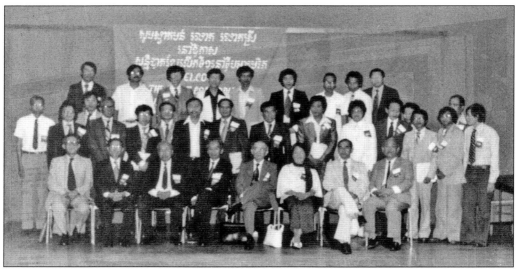

As the situation in Cambodia worsened, delegates and representatives of Cambodian groups from across the nation wanted to unite under one national organization. The Cambodian Association of America (CAA) was incorporated on December 29, 1975. This group picture is from the first national conference of Cambodian groups from across the United States. The conference, held in Long Beach in 1976 and aimed at mobilizing resources, came together to ensure the refugees received the needed support and understanding from fellow Cambodians and their new country.

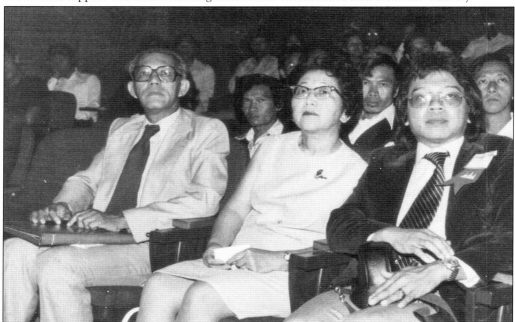

In attendance at the first national conference of Cambodian groups was, from left to right, Gen. Pok Sam An, Eunice Sato (Long Beach city council member, seventh district), and Prince Sisowath Sirirath. This picture illustrates how the Cambodian community in Long Beach drew the attention and support of Cambodian political and military leaders, as well as local non-Cambodian leaders.

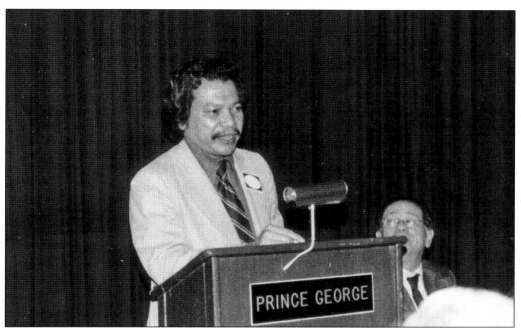

Sem Yang, the first president of the Cambodian Association of America (CAA), was responsible for representing the needs of Cambodian refugees both locally and nationally.

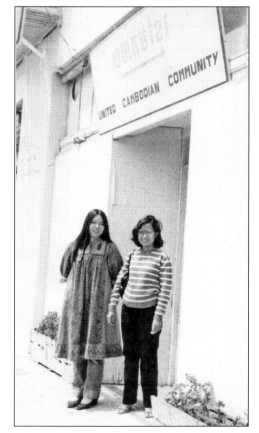

Cambodian leaders involved in the creation of the CAA eventually split off and developed a second social service organization, the United Cambodian Community, Inc. (UCC), in 1977. San Thi Tran (right) and an unidentified woman stand in front of the first UCC building/offices in Long Beach.

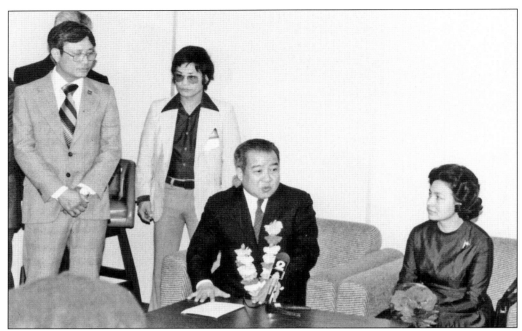

Prince Norodom Sihanouk (seated on the left) and his wife, Princess Monique, visited Long Beach the year after the overthrow of the Khmer Rouge by the Vietnamese in 1979. Many of the surviving students from the 1960s helped to coordinate the visit, including Lu Lay Sreng (standing on the far left), a former California State University, Long Beach, student and successful businessman in Long Beach.

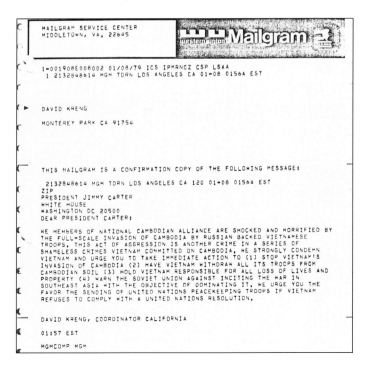

Most Cambodians in the United States saw the Vietnamese as "aggressors" and not liberators from the Khmer Rouge. This mailgram was sent to Pres. Jimmy Carter on January 8, 1979, to appeal for U.S. support for the withdrawal of the Vietnamese troops from Cambodia.

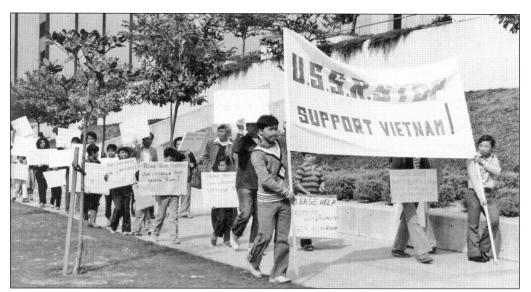

In 1979, Cambodians protested against Russian support of the Vietnamese in Cambodia. This picture shows the large crowd of Cambodian protesters marching in downtown Long Beach toward city hall. The protest gained more prominence since Moscow was hosting the 1980 Olympics, and Cambodian leaders used the anti-Communist sentiment to draw more public attention to the plight of Cambodian refugee issues.

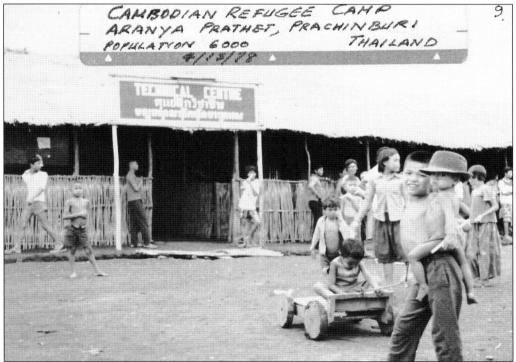

David Viradet Kreng took this picture of a refugee camp along the Thai-Cambodia border on April 18, 1978.

This photograph shows a family living in the refugee camp known as Site II, the largest of the camps on the Thai-Cambodia border.

An unidentified young man prepares a garden plot in a refugee camp along the Thai-Cambodia border in 1978. Gardening was a way to recreate a familiar daily rhythm for Cambodians whose primary occupations included farming and fishing. These plots also provided needed nutritional supplements to the meager rations available in the camps.

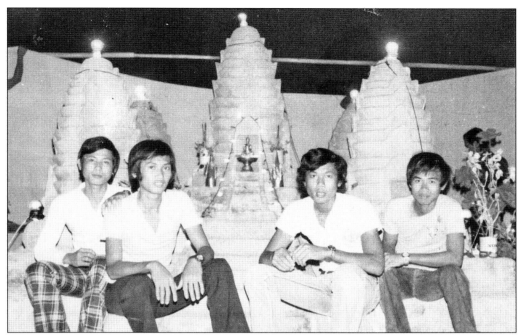

This picture was taken at the Philippine Refugee Processing Center near Morong Bataan, the final stop before permanent resettlement in a Western country. Some young men sculpted a replica of Angkor Wat as a cultural symbol of the endurance of the Khmer culture. Pictured from left to right are Chris Chan, Peter Long, Danny Chang, and David Lim.

This picture was taken in Khao-I-Dang, a refugee camp along the Thai-Cambodia border. The young woman was a part of the effort by Cambodians to revitalize traditional dance and other cultural practices in the camps.

29

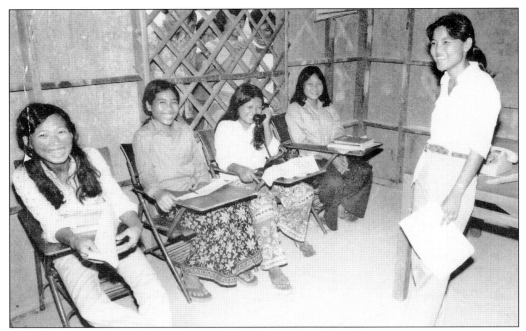

The Office of the United Nations High Commissioner for Refugees set up educational programs in the camps to help facilitate the transition into a Western country. This picture shows a group of young women in an English as a Second Language (ESL) class learning how to use the telephone.

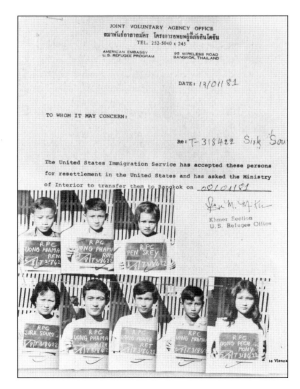

A letter from the Joint Voluntary Agency Office, an American contractor responsible for screening Cambodians, was required to enter the United States and meant the start of a new life.

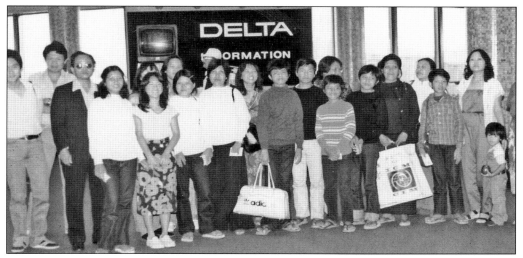

The Kem family is greeted at the airport in San Francisco, California, their point of entry into the United States before departing to Long Beach c. 1980. The bag held by Phann Kem (on the right) contains all of the family's travel documents. Her son Sodarin Kem (center) carries the only personal possessions the family had when they arrived.

This picture of Huot and Houy Lor was taken shortly after their arrival to Long Beach in 1979.

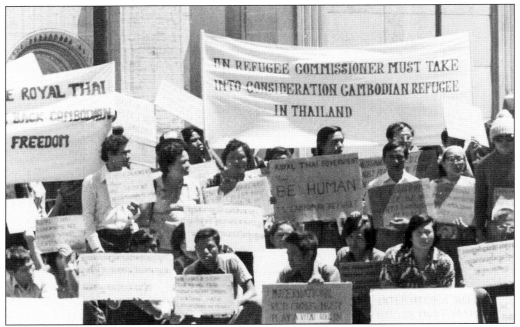

In June 1979, the Royal Thai Government forced the repatriation of 42,000 Cambodian refugees across the border at Preah Vihear. Local Cambodians appealed to the United Nations and world to save the lives of vulnerable refugees. The protest took place in Los Angeles.

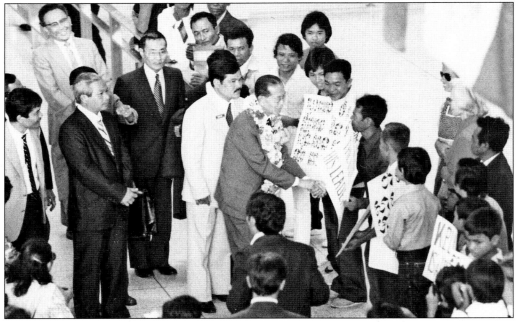

In 1988, H. E. Son Sann, the president of the Khmer People's National Liberation Front, came as the special guest of the United Cambodian Students of America and the Cambodian Student Society of California State University, Long Beach. He is pictured here being greeted at the airport by Cambodians anxious to find out about the current issues in Cambodia.

Three

RELIGIOUS PRACTICES

The majority of Cambodians in Long Beach are Theravada Buddhists. The form of Buddhism they practice incorporates animistic beliefs and Hindu elements. Traditional Cambodian culture centered on the daily activities of the *Wat*, the Khmer word for the Buddhist temple complex. The *Wat* was not only the religious center, but also the social and educational center of village life. Buddhist monks served laypeople in many ways, including providing psychological support and relief. The establishment of a Buddhist temple was critical for the emotional and mental health of all Cambodians but especially those who had lived through the Pol Pot time. In 1979, the Venerable Dr. Kong Chhean, who had been studying in India when Cambodia fell to the Khmer Rouge, was sponsored to the United States by members of the Long Beach community and set up in a small temple in an apartment in nearby Hawaiian Gardens. The first Buddhist temple located in the city of Long Beach was Wat Vipassanaram, established on Twentieth Street in 1985. Today there are more than 10 Cambodian Buddhist temples of varying sizes serving different segments of the population within Long Beach.

Christians were a minority in Cambodia prior to 1975, comprising about one percent of the population. A much larger percentage of Long Beach Cambodians are Christian for various reasons, including exposure to Christian aid workers in the refugee camps in Thailand, the high number of Christian individuals, churches, and organizations that sponsored Cambodians to the United States in the early years of migration, and continuing contact with Christians in the United States after resettlement. Upon arriving in Long Beach, many young Cambodians found church activities offered a good opportunity for meeting Americans and learning English. Many more congregations exist than were included here. The Cambodian congregations included here are among the earliest to form in Long Beach.

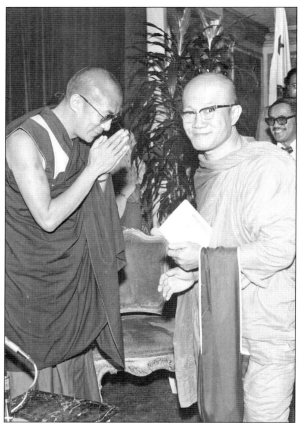

The Venerable Dr. Kong Chhean (right) meets with the Dali Lama (left) in 1979 in Los Angeles. David Viradet Kreng, who played a major role in helping to establish the Long Beach community, is in the background. Born in Cambodia, the Venerable Kong Chhean had been studing in India at the time Cambodia fell to the Khmer Rouge. He was sponsored to the United States in 1979 to establish a Buddhist temple for the Long Beach community. (Courtesy of the Venerable Dr. Kong Chhean.)

Students and teachers from an English language class stand in front of the Wat Khemara Buddhikaram (Khmer Buddhist temple) where social programs and English classes were provided throughout the 1990s. The temple, headed by Dr. Kong Chhean (center), moved to its current location in the former Oil, Chemical, and Atomic Workers International Union Hall at 2100 Willow Street in 1989. The Khmer lettering on the building translates to *Wat Khmer.*

The first Cambodian Buddhist temple established in the city of Long Beach was Wat Vipassanaram (Meditation Temple) located at 1239 East Twentieth Street in 1985. It is so named because the head monk, the Venerable Horm Hem (pictured here), practiced meditation regularly and taught it to his followers.

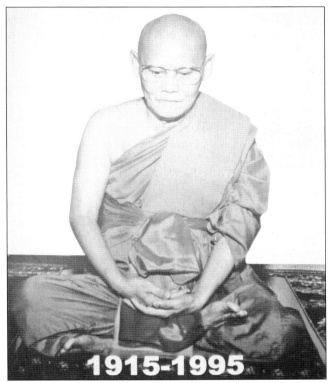

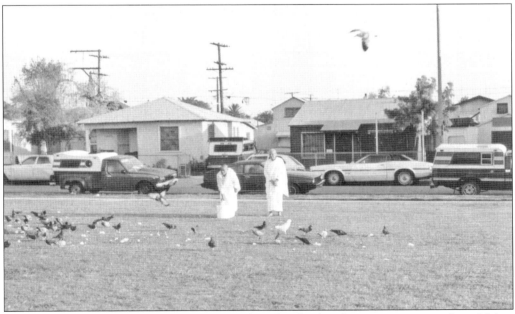

This exterior view of Wat Vipassanaram was taken shortly after the property was purchased. Most of the Cambodian Buddhist temples in Long Beach are located in renovated homes. The two women are *look yeiy*, or "respected grandmothers," who have retired into the temple to meditate and prepare for the next life.

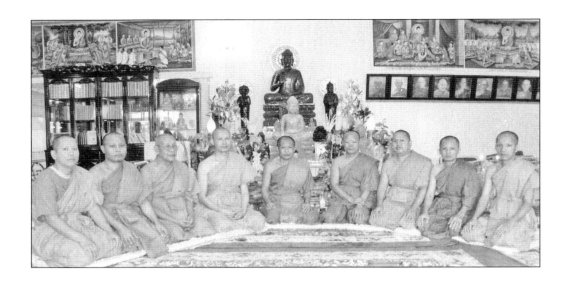

Wat Sakor Borei, located at 2289 Lewis Avenue, is pictured during a special ceremony in 2002. The monk at the far left was a police officer visiting from San Diego who was in residence for one month. Becoming a Buddhist monk is not a lifetime commitment. Traditionally, all adolescent males were expected to spend some time as novice monks in their local village temple, but the decision to continue as a monk or return to secular life was largely up to the individual. It was also possible for men to return to the monkhood after an absence of several years. The other monks pictured here are (starting second from left) Sophea Chan, Keng Kem, Lok Ta Chea (visiting from Australia), Peow Say, Sareth Chhiv, Sakeoun Saet, Thorn Saveoun, and Kim Hon. Below is an exterior view of Wat Sakor Borei.

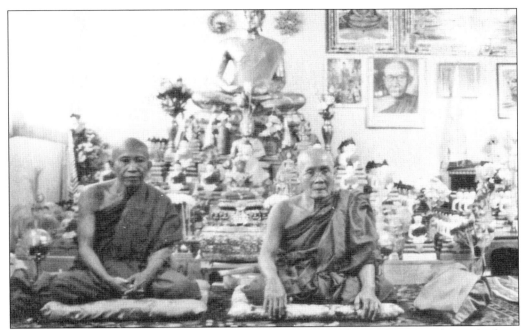

Not all Cambodians in Long Beach are of Khmer ethnicity alone. Many are of mixed ethnic backgrounds, which include Chinese, Lao, Thai, and Vietnamese. Wat Chansisothavaskaub, located at 2312 East Spaulding Street, was founded in 1989 to serve a Khmer-Lao congregation. This photograph is of the Venerable Tep Vong (left), supreme patriarch of Cambodian Buddists in Cambodia, who was visiting in 1992, and the head monk, Venerable Om Sum.

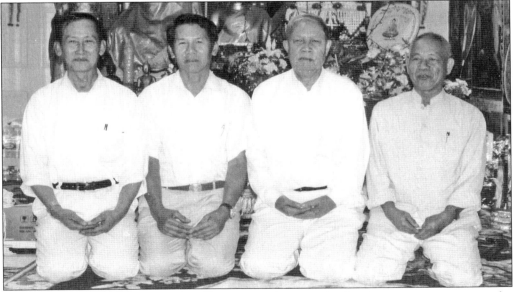

Since Buddhist monks may not handle money, a lay organization is necessary to oversee the operations of the temple. Pictured is the group of men responsible for Wat Chansisothavaskaub. Shown from left to right are Choer Sisaat, the temple *pratien*, or president; Lok Nam; Liem Sy; and Samon Tim.

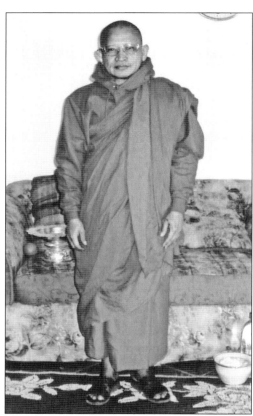

The Venerable Bunnarith Nuon is the head monk of the Market Street Community Center and Wat Bothiprikrattanaram, located at 1949 East Market Street in North Long Beach.

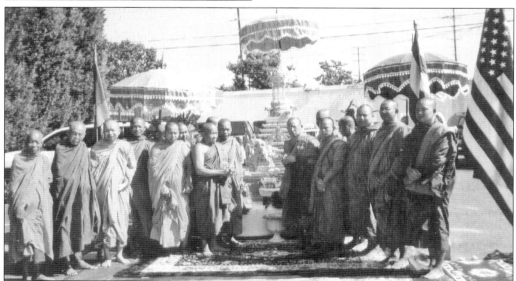

Many Buddhist events and ceremonies require a larger number of monks than are in residence at any given temple. Their presence increases the blessings and honor associated with the occasion. Monks from all over Southern California gathered to dedicate Wat Bothiprikrattanaram and the Market Street Community Center in 2005.

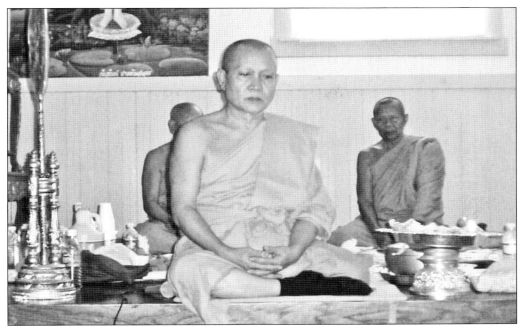

Venerable Thong Souk became head monk at Wat Samaki Dhammaram, located at 1056 Cherry Avenue, in July 1986. The Wat moved to its present location in a former Christian church at 2625 Third Street in July 1998.

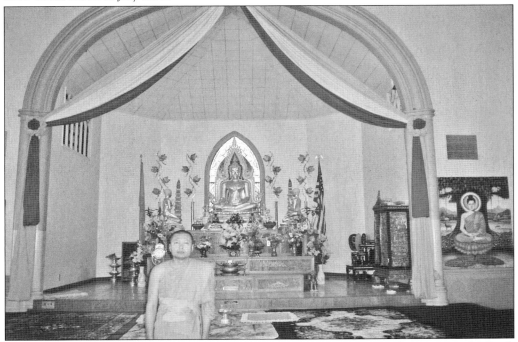

Venerable Dr. Dork Rak stands in front of the Buddha at Wat Samki Dhammaram. Dr. Dork Rak is Thai and does not speak Khmer. This temple serves mostly Khmer but also Thai who are from Cambodia, Laos, Vietnam, and Burma.

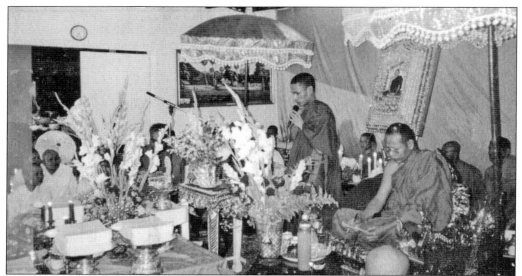

Sao Ouer helped to establish Wat Sonsam Kusal on South Street in 1997. Sao is no longer a monk but continues to live at the temple and participate in its many ceremonies and activities. Sao is pictured here in 1997 leading a memorial service for his teacher, a Cambodian monk in Cambodia. The seated monk is visiting from a Cambodian temple in Santa Ana in nearby Orange County.

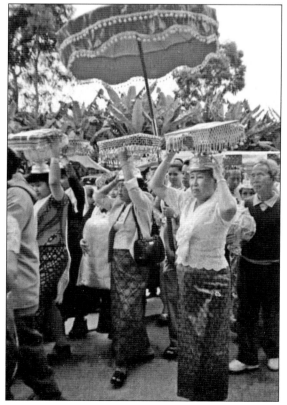

This photograph of a Bun Kathin ceremony at Wat Sakor Borei was taken in October 2002. Bun Kathin is one of the annual ceremonies of the Theravada Buddhist calendar, marking the end of the rainy season in Cambodia. People bring offerings of new robes and other necessities to the monks who, according to tradition, are not allowed to leave the temple compound during the rainy season. The robes are placed on a silver tray with a beaded cover over them and carried to the temple on the head. This photograph was taken in the temple courtyard as everyone gathered to form a procession to bring the gifts to the monks.

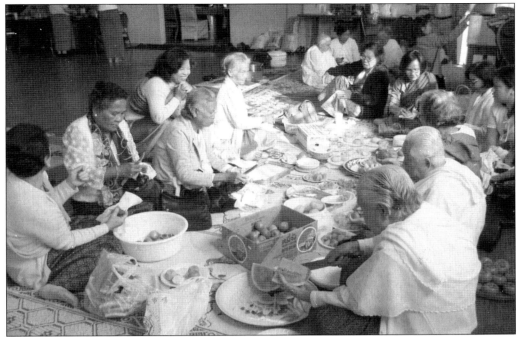

People bring food to the temple for the monks and to receive a blessing. This photograph was taken at Wat Khemara Buddhikaram during Bun Kathin in 2001. Pictured above, women help prepare special dishes of fruit and desserts.

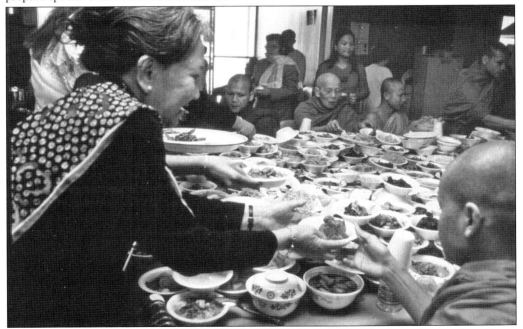

Small amounts of food are placed in dishes, which are set on the table where the monks will eat. The monks eat first, and when they are done, the food is shared among those who came for the celebration. (Courtesy of Kayte Deioma Photography.)

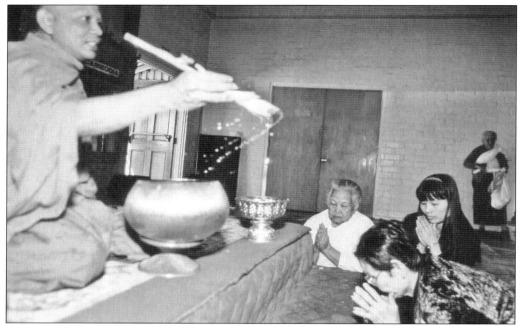

A monk blesses the congregation at a ceremony at Wat Khemara Buddhikaram. (Courtesy of Kayte Deioma Photography.)

Classes in Khmer literacy have been offered by many organizations since the early days of the community. The Sunday Khmer literacy class at Wat Khemara Buddhikaram has been taught by Kiry Tham since the early 1980s.

Venerable Dr. Kong Chhean teaches a Khmer language class to a group of young adults in 2001. Most members of the class were also members of C-HOPE (Cambodian Humanitarian Organization for Peace on Earth). Pictured from left to right are Socheata Has, Domnang Meas, Ponchivy Tan, Venerable Kong Chhean, Pok Khem, Sith Nip, Sompia Paigne, Kaneka Chhim, and Oun Chhim.

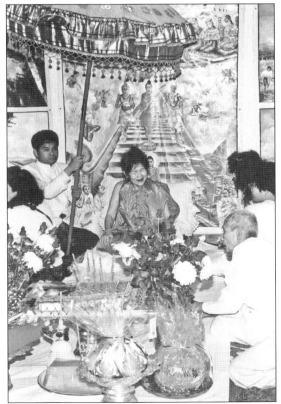

In addition to Buddhist ceremonies, rituals honoring Khmer ancestors, known collectively as *neak ta*, have been conducted in Long Beach. On Saturday, March 3, 1996, Sakphan Keam sponsored a public Spirit Flag Raising ceremony for community healing and to honor Lok Ta Okgna Khleang Moeung, a Cambodian army officer from 16th-century Cambodian history. Heng Kim, a respected Cambodian medium living in nearby La Puente, officiated the ceremony. She is shown here during the ceremony, dressed in monk's robes of orange silk. (Courtesy of Kayte Deioma Photography.)

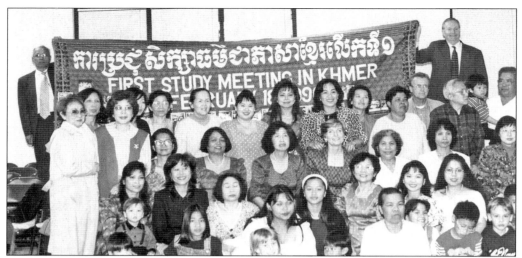

Many Cambodians also practice Nichiren Daishonin Buddhism with the lay organization Soka Gakkai International, whose activities focus on the promotion of peace, culture, and education. The first Khmer language study meeting was held in 1994 at the Santa Ana Community Center.

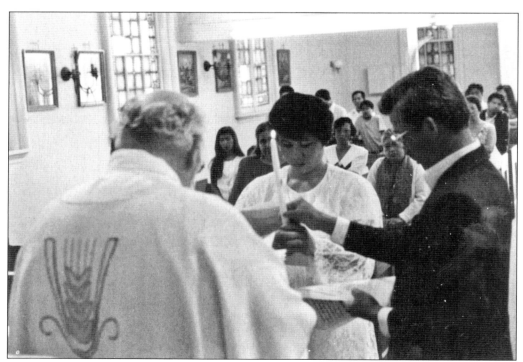

Christianity was introduced to Cambodia in the 1500s by Portuguese explorers. Today some 300 Cambodia Catholics live in Southern California. Founded in 1992, Our Lady of Mount Carmel Cambodian Center, located at 1851 Cerritos Avenue, is the only Cambodian Catholic congregation in the state of California. Fr. Rogation Rondineau of the Missionaires Etrangeres des Paris came to the United States to serve the refugee population in 1984 after 30 years in Cambodia.

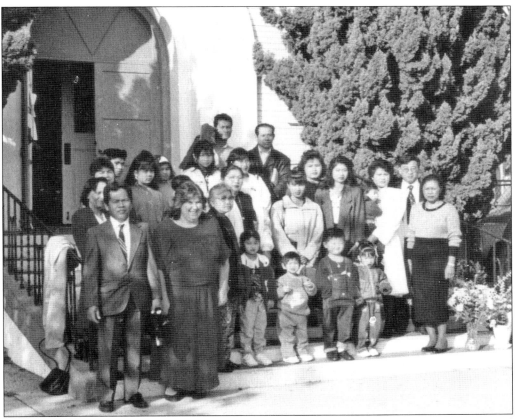

Mary Blatz (second from left) has served as the lay director since Our Lady of Mount Carmel Cambodian Center was founded. Built in 1902 and originally named St. Anthony's, the church building was moved from Sixth Street and Olive Avenue to Cerritos Avenue in 1923. It is the oldest Catholic church in Long Beach.

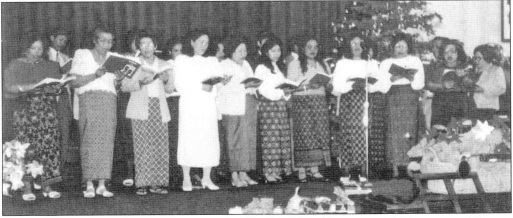

The Long Beach Cambodian Evangelical Church of the Christian and Missionary Alliance was founded by Rev. Paul Ellison, Rev. Hay Seng San, and Chhem Nhem in July 1978 and is one of the first Cambodian Christian churches in the United States. It is located at 2416 East Eleventh Street.

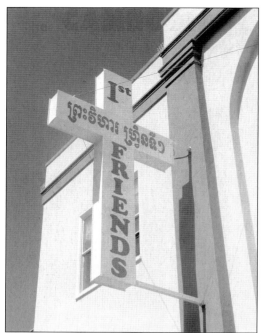

Long Beach Friends Church, located at 850 Atlantic Avenue, began its Cambodian ministry in late 1979. By 1981, over 100 Cambodians were attending Sunday services. In a pattern similar to later churches, the Friends congregation formed an assistance center under Cambodian leadership to meet basic needs. They offered ESL classes and helped with such things as finding a place to live, opening bank accounts, and transportation to doctor appointments.

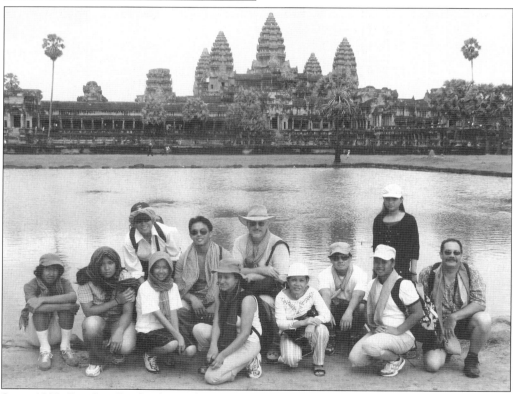

Since 1995, Rev. Joe Ginder (second row, center), minister at Long Beach Friends Church, has led members of the congregation on trips to Cambodia and Angkor Wat.

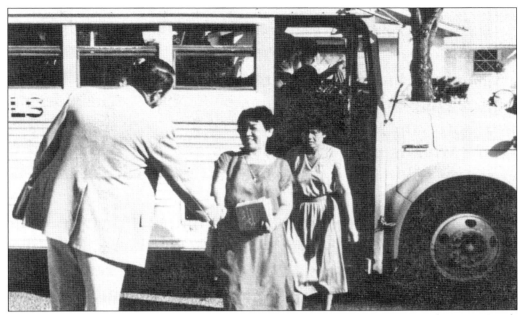

This photograph shows two Cambodian women arriving for Sunday service at the Long Beach First Church of the Nazarene on Clark Avenue in 1979 as part of the church's "bus ministry." By 1984, over 300 Cambodians of Khmer and Lao descent were attending Sunday services each week. (Reprinted with permission from A. Brent Cobb.)

In 1986, the Khmer and Lao Nazarene congregations moved to their new home at 1800 East Anaheim Street and became the Long Beach New Life Church of the Nazarene. By 1988, they had over 1,000 members and were the largest ethnic ministry in the Church of the Nazarene. Rev. Anong Nhim serves as their pastor.

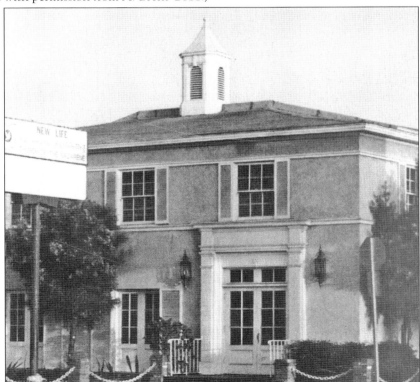

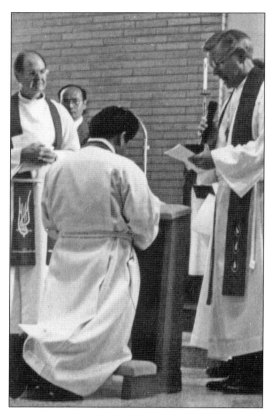

The Cambodian congregation of the First Lutheran Church, located at 905 Atlantic Avenue, began in 1982 when two families, the Soks and the Saos, visited the church. A Cambodian Bible study class was formed shortly after, and a separate Cambodian worship service was begun in 1983. Rev. Chandara Lee was installed as lay pastor to the Cambodians at the First Lutheran Church in 1989. After completing his ministerial studies, he was ordained in a ceremony at First Lutheran on April 29, 2001. Pastor Lee was the first, and may still be the only, Cambodian Lutheran minister in the United States.

The Church of Jesus Christ of Latter-day Saints, located at 1140 Ximeno Avenue, is home to the first and only Cambodian ward in Mormon church history. The Cambodian ward had its beginnings in 1979 when Cambodians began attending services at the ward on Pine Avenue. Members gather for a group photograph on Sunday, February 27, 2005, to commemorate becoming the first Cambodian ward. Jeffrey A. Parry serves as their bishop.

Four

THE ARTS

The Cambodian dance, music, and material arts of today are remarkably similar to those depicted on the walls of the great temples of the Khmer Empire from the 9th to the 15th centuries. After Cambodia was invaded by the Vietnamese in 1979, Cambodians in exile feared their country and culture would soon be lost, and those who could sought to teach what they knew to their children and other students. In Long Beach, dance troupes, music ensembles, and artists have worked hard to preserve their art forms and transmit their knowledge to a new generation growing up in the United States.

Two forms of dance most often seen here are the highly stylized classical dance and the folk dances adapted from those performed in rural areas of Cambodia. Classical dance was originally performed as part of Hindu worship. Dance troupes were composed of women who performed all the major roles. Since the 1950s, males have performed the physically strenuous monkey roles. Only the king and other high officials could afford to maintain a dance troupe, and few ordinary Cambodians ever saw this dance. Since the 1970s, however, classical dance has become a symbol of Cambodian culture and is now performed all over the world.

Cambodian music and song holds a special place in the hearts of Cambodians. As explained in a program from the 1988 opening of the United Cambodian Community, Inc., (UCC) Vocational Center:

> Song is the most spontaneous and natural means of expression in the life of Cambodian people. Almost all aspects of living, from birth to death, are accompanied by . . . music and song. This is because music is the Cambodian's soul. It is with him in happiness and in sorrow. It is the expression of his being, of his humanity, of his Cambodian-ness.

The photographs in this chapter show some of the dance, music, theater, and material arts being produced in Long Beach. The selection of artists presented here is limited to those people the authors were able to reach while collecting photographs for the book.

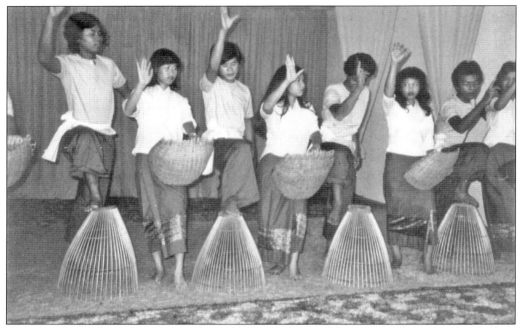

This photograph from 1982 or 1983 shows the dance troupe of the UCC performing a Cambodian folk dance, the Fishing Dance. The baskets are fish traps used in the rural areas of Cambodia. The troupe performed all over Southern California.

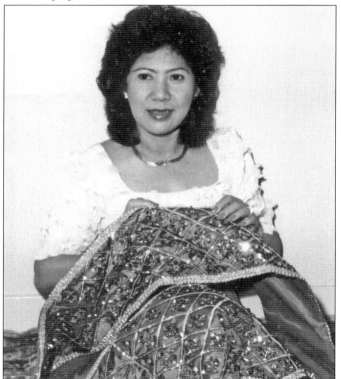

Costumes and materials from Cambodia were not available in the United States in the early days of the community. Everything had to be made by hand from memory. Leng Hang, depicted here adding beads to a shawl used in Cambodian classical dance and weddings, had been trained as a dancer and actor while in the Cambodian army in the 1960s. She founded the Cambodian Arts Preservation Group in 1983 in Long Beach.

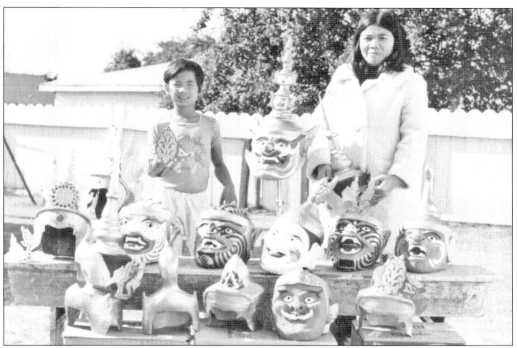

Pictured here is a collection of masks made by Yon Pich in the early 1980s for Cambodian performances.

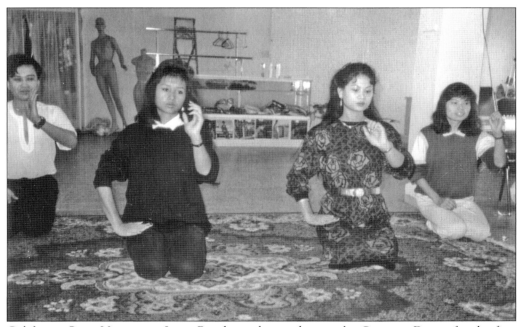

California State University, Long Beach, students rehearse the Coconut Dance for the first student-produced Cambodian culture show in 1987.

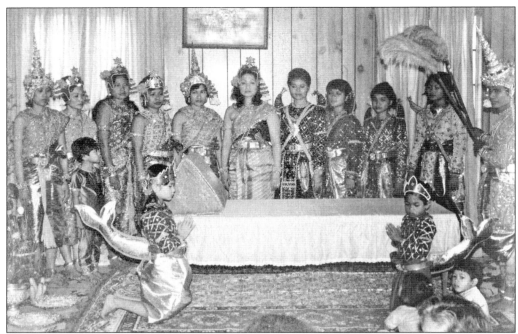

Rina Uch (fourth from left) made costumes for a dance troupe in Long Beach. This photograph was taken in 1988.

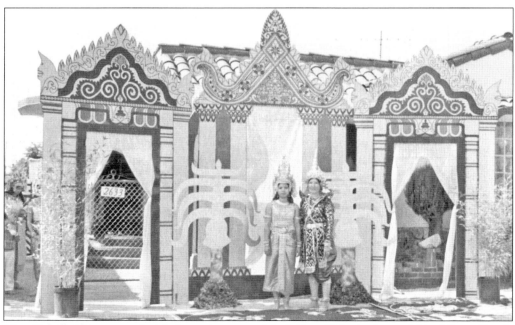

Rina Uch (left) is pictured with dance instructor Neak Kruu Sitho in front of Rina's Long Beach home. Rina's husband built the facade in the likeness of a 9th-century Khmer temple known as Banteay Srey for a performance.

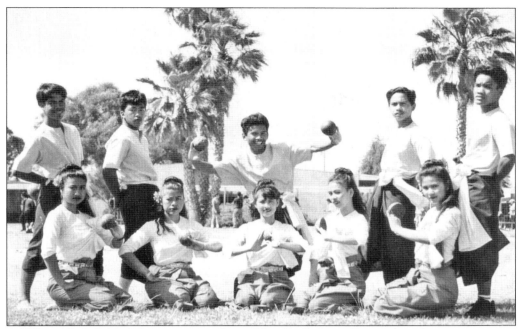

A Wilson High School dance group is dressed for the Coconut Dance, based on a game using coconut shells.

Between 1993 and 1998, Lincoln Elementary School had a cultural program for their students that included dance performances.

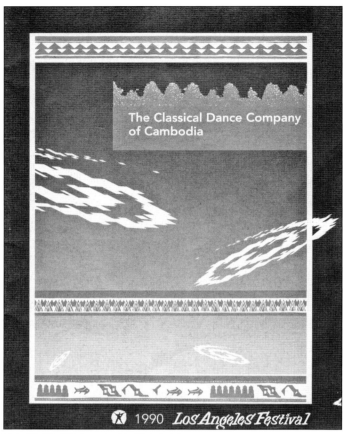

The Classical Dance Company of Cambodia

1990 *Los Angeles Festival*

In 1990, the Classical Dance Company of Cambodia, under the artistic direction of Proeung Chhieng, performed in the Los Angeles Festival. It was the first tour of dancers in the United States since 1971 and, for many Cambodian Americans, the first contact with Cambodia since fleeing in the 1970s and 1980s. It was an emotionally charged tour that confirmed that the country and culture had not been destroyed. Below, the troupe relaxed on a Southern California beach during their visit.

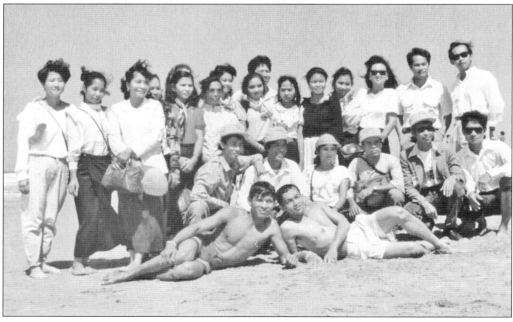

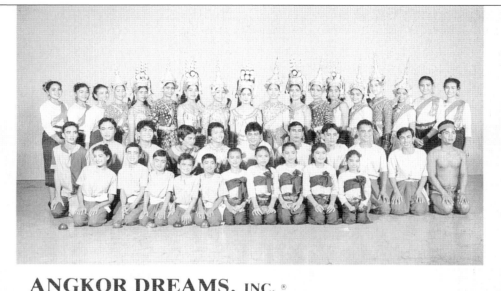

ANGKOR DREAMS, INC. ®
1991 U.S. Tour

Angkor Dreams Dance troupe from the Site II refugee camp in Thailand made a short tour of the United States in 1991.

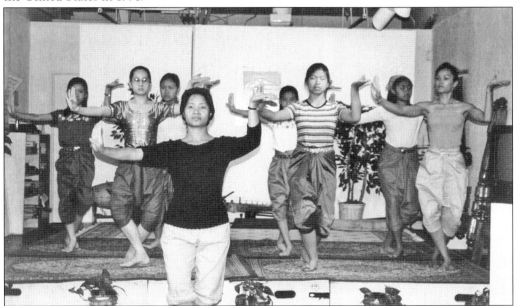

Sophiline Cheam Shapiro is shown here leading a class at the Arts of Apsara where she was the program director from 1999 to 2002. She was trained in Cambodia at the School of Fine Arts and was a member of the dance troupe that performed at the Los Angeles Festival in 1990. She moved to Los Angeles in 1991 where she began teaching classes in Cambodian classical dance and majored in dance ethnology at UCLA. Today Sophiline is an internationally acclaimed choreographer, retelling familiar stories such as *Othello* through classical dance and creating original pieces. She opened the Khmer Arts Academy in Long Beach in 2002.

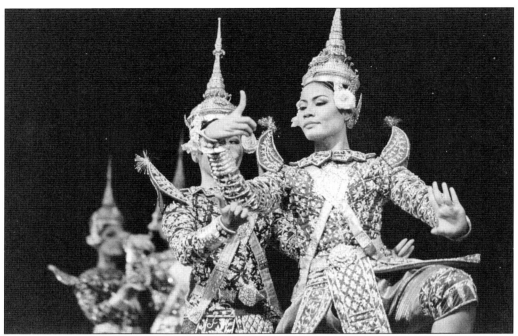

Seasons of Migration, an original piece choreographed by Sophiline Cheam Shapiro, had its world premiere in Long Beach in 2005. This photograph gives a sense of the elegant and intricate costuming that is part of Cambodian classical dance. (Courtesy of Michael Burr.)

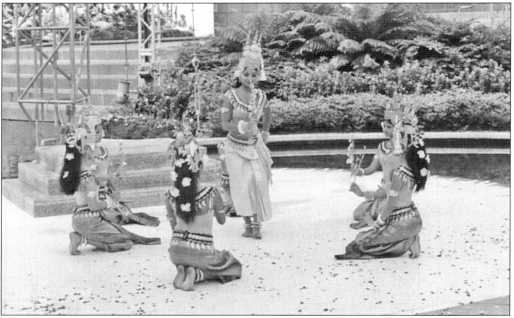

Khmer Arts Academy students perform Apsara Dance at Grand Performances in Los Angeles in 2004. The Apsara Dance was created in the 1950s and is based on the bas reliefs of celestial dancers carved into the walls of Angkor Wat. It tells the story of celestial dancers descending to earth to gather flowers.

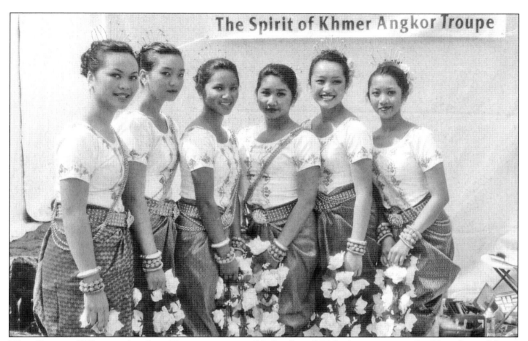

The Spirit of Khmer Angkor Troupe was established in 2003. Approximately 55 girls and boys attend Saturday classes to learn Cambodian classical dance and music. The troupe is supported, in part, by the Cambodian Association of America.

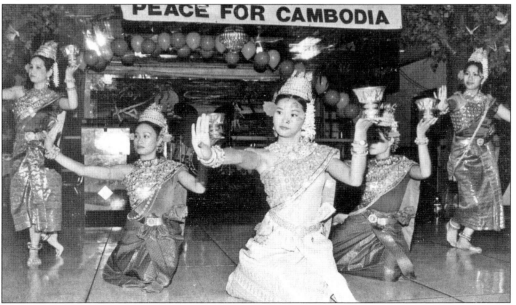

The Cambodian Arts Preservation Group performs the Wishing Dance at a Cambodian gala event. The Wishing Dance is traditionally the first dance performed in a program. The dancers hold silver cups containing flower petals, which they release toward the audience, spreading good wishes and prosperity to those in attendance. Leng Hang's daughter, Gloria Keo, (center) is the principal dancer.

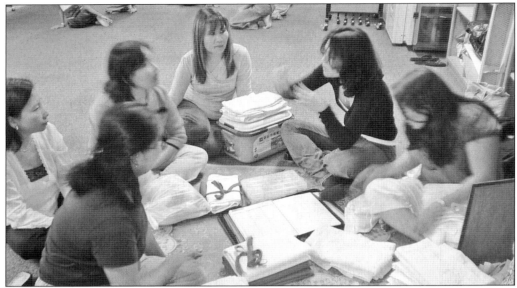

Dance and music classes involve the whole family, including siblings, cousins, parents, aunts and uncles, and grandparents. Families support the dancers by providing transportation and food, dressing dancers, and generally filling in wherever necessary. Shown here, the mothers of the Spirit of Khmer Angkor Troupe are organizing the costumes for an upcoming dance performance. Traditional Cambodian dance costumes have no buttons, zippers, or fasteners of any kind. The dancers are sewn into their costumes before each performance. It takes almost an hour to dress each dancer and requires skilled dressers.

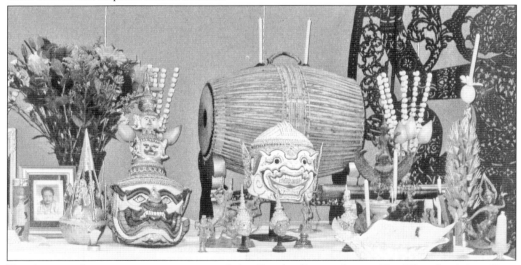

Teachers and ancestors are venerated in Cambodian culture. On Thanksgiving Day, November 23, 2006, the Spirit of Khmer Angkor Troupe held a *Sompeah Kruu* to give thanks to the ancestors of Cambodian dance and to ask for blessings. According to tradition, this ceremony is performed on a Thursday before noon. All the elements of Cambodian dance, music, and theater, including costumes and instruments, were placed together on a table with candles and offerings of food. Prayers were chanted, and music and dances were performed for the benefit of the ancestors.

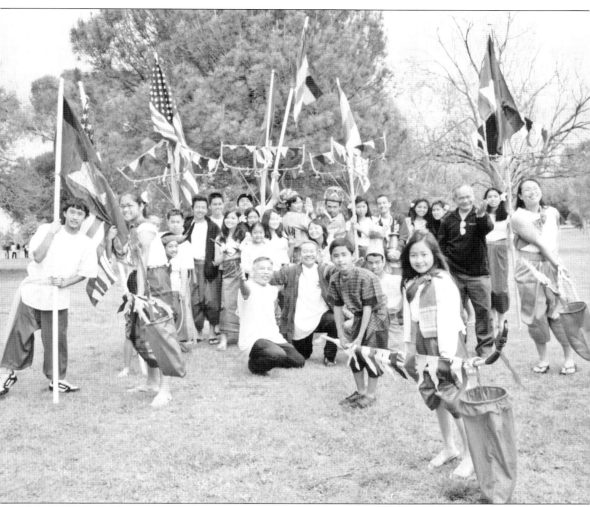

Pictured is a *trot* dance group from a recent Cambodian New Year celebration at El Dorado Park. In Cambodia, the *trot* groups raise money for their local Buddhist temples. They go from house to house collecting offerings, singing and dancing for anyone they meet along the way. Large red bags are attached to the ends of long bamboo poles into which spectators place their offerings.

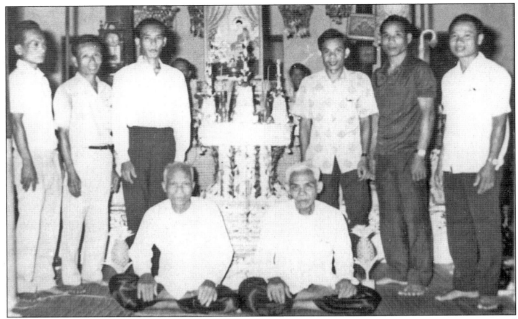

Cambodian traditional music is as ancient and rich as the dance. Because it was not notated but was transmitted orally from one generation to the next, many Cambodians in exile feared the musical knowledge had been wiped out by the Khmer Rouge. Long Beach is fortunate to have had master musicians living and performing here. This photograph, taken in Cambodia before 1975, shows Long Beach musician Ho Chan's grandfathers, Chheas Nov (seated, right) and Chuch Chan (seated, left).

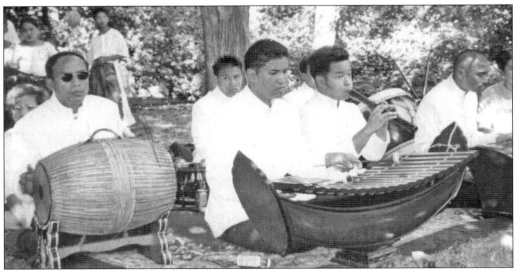

A few young Cambodian boys growing up in Long Beach have shown interest in learning to play the traditional instruments and music. Here Master Ho Chan (far left) performs with his students who have studied with him for a number of years.

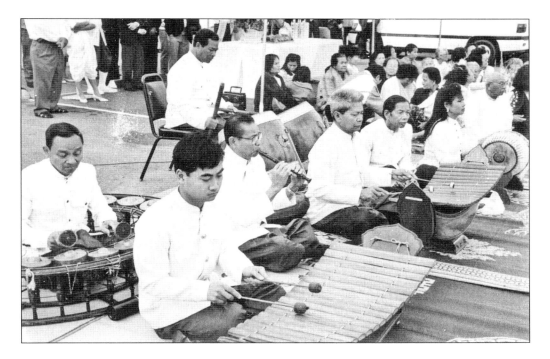

Yinn Pon, a master musician in Long Beach, is shown above playing the flute with his ensemble. At the time this photograph was taken, Master Yinn Pon was the oldest surviving Cambodian musician living in the United States. In 1990, the Long Beach City Light Opera received funding to stage a performance of *1776* for the Cambodian community (below).

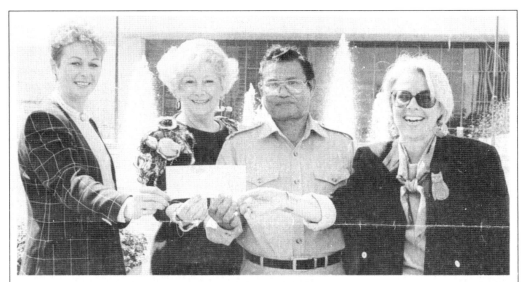

New Americans, Old Americans

GTE's Robin Koons, District Manager Community Relations, presents a check for $10,000 to LBCLO Vice Chairperson Betty Hill, joined by musician Mr. Yinn Pon and Bonnie Lowenthal, Director of Planning, United Cambodian Community, Inc., for special performance for the Cambodian & Asian communites of 1776 in July 1990.

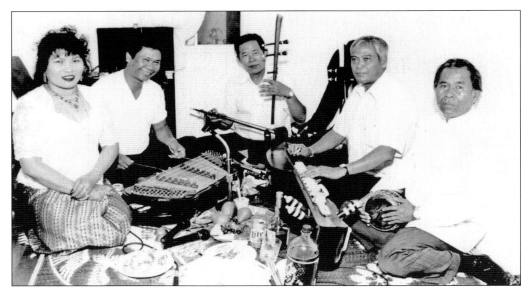

Included in this Long Beach musical ensemble in 1989 are, from left to right, Srey Hom, Sum Yuth, Pan Keo, Nuth Vorn, and Chum Vat.

A new generation brings new perspective and musical forms. PraCh Ly, a well-known Long Beach rapper, was born in rural Cambodia and grew up in "the mean streets of America" in North Long Beach. He mixes both rap and traditional Cambodian musical forms to tell stories of the Cambodian genocide and life in the Cambodian community.

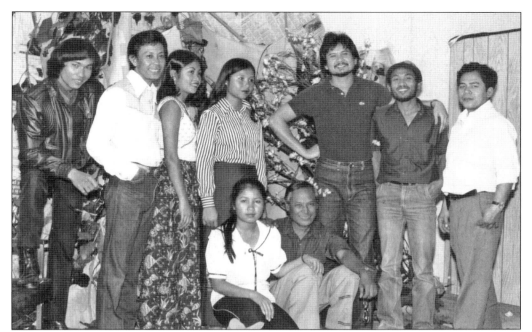

Kan Nuon (seated, right) was a professor at the University of Fine Art in Cambodia before 1975. He received a sponsorship from Japan, arranged by Than Pok, to direct the arts program at the United Cambodian Community, Inc. Shown here is the cast from the first production he directed in 1982, an adaptation of *Khaa Key*, a play written by King Sihanouk's family.

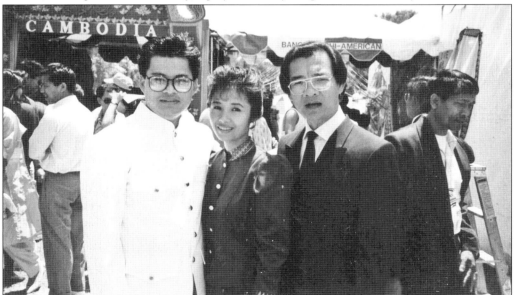

Although he did not live in Long Beach, Haing Ngor (right) was no stranger to the community. A physician by training in Cambodia, he received the 1985 Academy Award for Best Supporting Actor for his performance in the movie *The Killing Fields*. He is pictured here with Richer (left) and Sithea San in 1991 at a fund-raising event for Pres. George Bush Sr. in Mile Square Regional Park in nearby Orange County.

CHANTARA NOP & DIANNA KENLOW
THE DEAD ACCUSE , THE FOUND THEATRE

បងប្អូនពីរនាក់ស្រណោះម្ដាយ ពេលគាត់ហ្អាតឆ្ងាយដោយសារយួន
ចាប់ម្ដាយចេញទៅសល់បងប្អូន ទុក្ខគេផ្ដុនៗផ្ទុនលើគ្នា ។

Chantara Nop is a Long Beach actor, playwright, and poet who has appeared in such productions as *China Beach* and *The Golden Child* with Eddie Murphy. He is pictured at left in a production of Kan Nuon's *The Dead Accuse*. The Khmer poem was written by Chantara. Below, performers in an original play by Chantara Nop, *The Journey Across the Minefields to America*, which premiered at the Found Theater in Long Beach in 2006, are (from left to right) Patrick B. Ben, Justin M. Nop, Leng Kim Heng, and Sopho Kong.

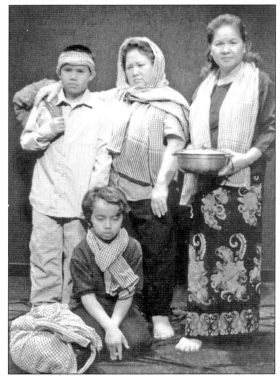

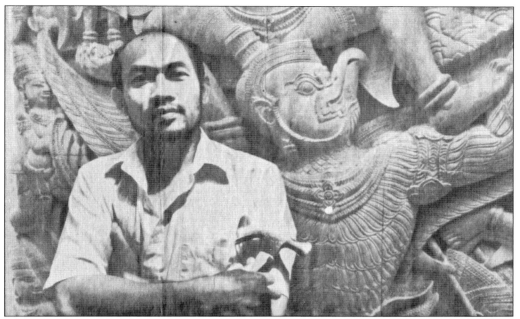

Chum Sambath, a well-known sculptor in Long Beach, is pictured here in a 1992 *Press-Telegram* article standing in front of a *garuda* he carved in sandstone. Sambath was trained in fine arts as a young man in Phnom Penh before 1975. He attended the Facultee Des Arts Plastiques and studied under Angkor art expert Bernard Philippe Groslier. (Courtesy *Press-Telegram*, June 15, 1992.)

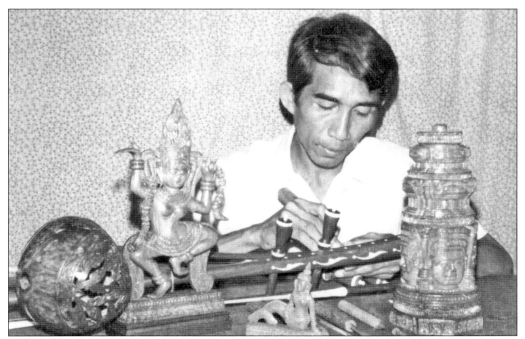

An unidentified carver is pictured with carved statues and a *tro*, a string instrument made from coconut shell and teak and inlaid with ivory.

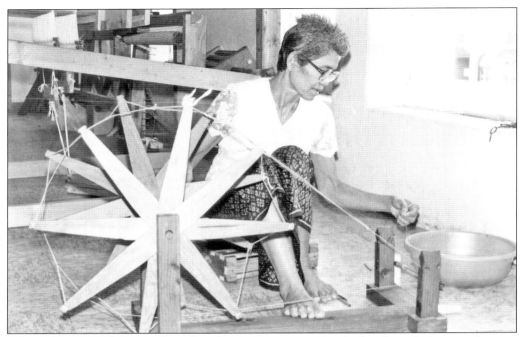

Silk production and weaving have long been important in Cambodia. As with dance and music, people in the early years of the community sought to re-create and maintain the art through special programs. These weavers were supported by the Arts of Apsara during the 1980s, a cultural center founded by the United Cambodian Community, Inc.

Five

COMMUNITY FESTIVALS AND CELEBRATIONS

Festivals and celebrations in the Cambodian community in Long Beach affirm the symbols and traditions of the culture. Cambodian community organizations, businesses, and cultural groups have been the driving force behind continuing the traditions of their homeland and re-creating them in a new context for Cambodians and the broader public. This chapter mainly focuses on Cambodian New Year festivities, since New Year is one of the most important times of celebration in Cambodia and in Cambodian communities around the world.

In Cambodian culture, *Choul Chnam Tmey*, which means "entering the new year," is celebrated traditionally over a three-day period beginning April 13th. Over the years, the precise date of the New Year festivities in Long Beach has been adjusted to accommodate work and school schedules, but this has not taken away from the significance of April as a time to focus on Cambodian public culture. Although New Year celebrations are held in other cities in California and across the United States, Long Beach is believed to have the largest and most elaborate events. The festivals and celebrations Cambodians have organized and participated in have transformed the cultural life of the city of Long Beach.

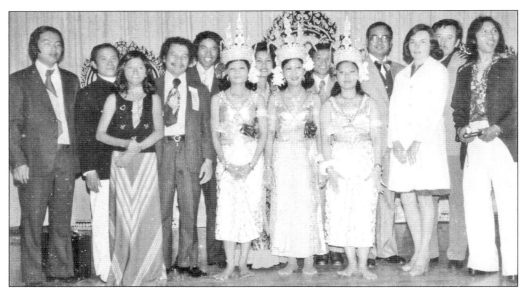

The first Cambodian New Year celebration after the arrival of refugees and evacuees to the Long Beach area was held at Wilson High School in April 1976. The New Year festival featured Leng Hang (center dancer), a well-known dancer in Cambodia, and provided Cambodians as well as non-Cambodians an opportunity to experience a professional cultural performance. After this performance, Leng Hang focused on teaching traditional dance to the younger generation and never performed publicly again.

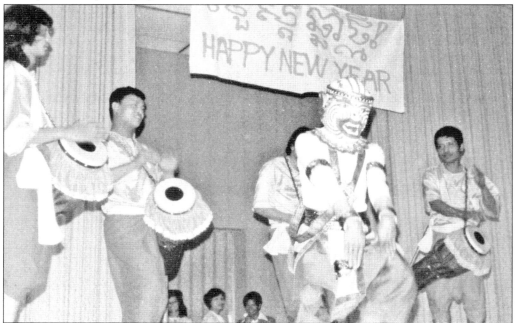

The Cambodian New Year celebration in 1977 featured Yon Pich performing Chhayam, a festive comic-style dance accompanied by brightly decorated log drums, cymbals, and wood clackers. Dancers perform exaggerated moves and engage in call and response singing, which is often nonsensical.

Cambodian New Year celebrations were also held at local parks where families gathered to share food, make religious offerings, and enjoy culture shows and traditional music. This picture, taken in April 1988, shows the outdoor stage and the crowd gathered at "Park 7," the name Cambodians gave to the recreation park on Seventh Street and Park Avenue.

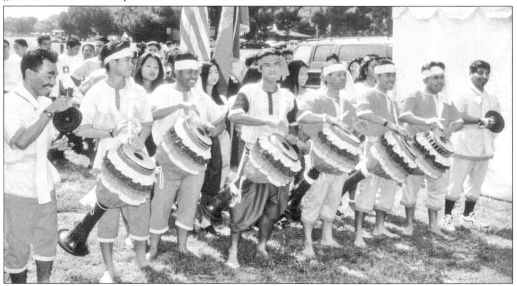

By the early 1990s, the Cambodian New Year event had grown too large to be held at Park 7. The festivities moved to El Dorado Regional Park, where thousands of Cambodians gather to celebrate, many of whom come from other parts of California and the United States. This 2000 picture shows a group of college students performing Chhayam, a lively dance that opens the Cambodian New Year performances. (Courtesy Kayte Deioma Photography.)

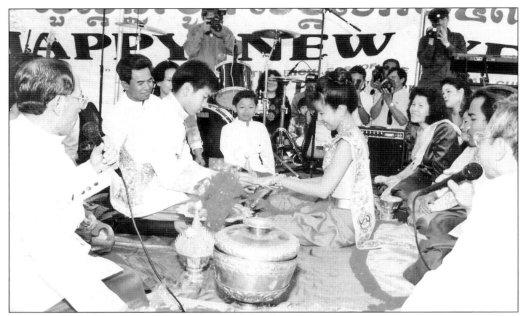

The Cambodian New Year festivities provide the older generation an opportunity to teach younger Cambodians cultural traditions. In this picture, taken at El Dorado Park in April 1997, a young man and woman participate in a mock wedding ceremony. The young couple is surrounded by elders and receiving instruction from them as a way to reinforce the importance of marriage as a bond made not only between the couple, but also one that binds the family and community together.

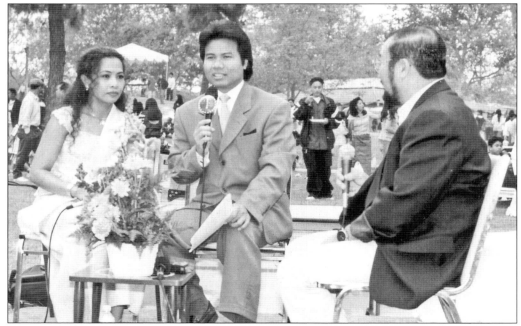

The Cambodian New Year festival in Long Beach is broadcast on Cambodian television. Ratanak Oeurn (center), a local television commentator, is seen interviewing an unidentified man.

The Cambodian New Year festival at El Dorado Park has not been free of controversy. The city increased the amount of security cost to such a degree that made it prohibitive for the Cambodian community to have the festival. The amount charged was not proportional to that required of other groups having large events in the city. Him Chhim, the executive director of the Cambodian Association of America at the time, is quoted in a Long Beach *Press-Telegram* newspaper article as saying, "That is simply discrimination. That is ethnic profiling." In the wake of the city refusing to negotiate a better contract, the festival at El Dorado Park was canceled, and instead, community members protested their unfair treatment. The Cambodian New Year festival has not been interrupted since this protest. (Photograph by Leo Hetzel; courtesy *Press-Telegram*, April 11, 2001.)

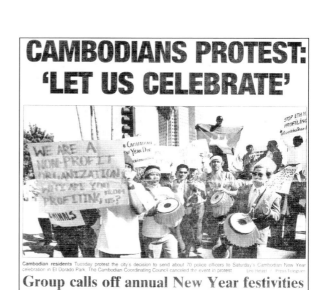

In 1999, the Cambodian Coordinating Council (CAM-CC), an organization that included 17 Cambodian organizations and groups, was formed to advance the interest of the Cambodian community. One of their roles has been to organize the New Year festival and to negotiate with the City of Long Beach all contracts that affect these events. This picture shows members of CAM-CC with other community leaders at the main performance stage of the 2002 New Year festival, a momentous event after the preceding year's protest. Pictured from left to right are Bryant Ben, Laura Richardson (Long Beach City Council member, sixth district), Bonnie Lowenthal (Long Beach City Council member, first district), Danny Vong, Him Chhim, Tippana Tith, PraCh Ly, Kim Suor Ngann, Andrew Dani, Pasin Chanou, and Phylypo Tum.

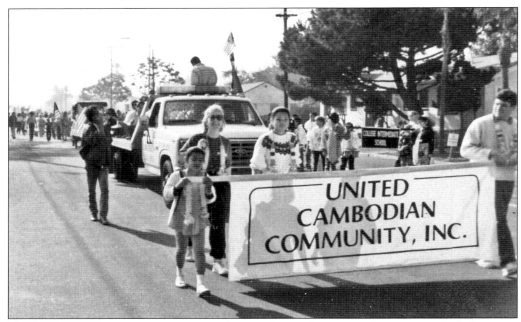

Cambodian community agencies not only provide social services, they serve as links between Cambodians and the broader society. The United Cambodian Community, Inc., participated in the Martin Luther King Day Parade, shown here in the early 1990s.

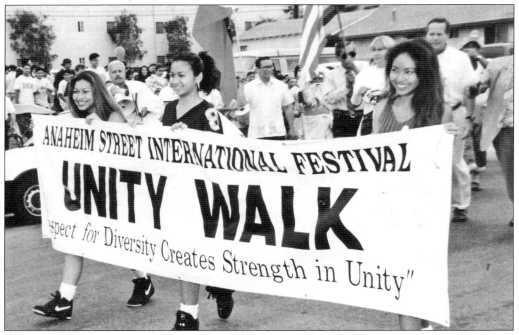

The Cambodian Business Association, along with the City of Long Beach, organized the Anaheim Street International Festival and Unity Walk (pictured here in 1993) to promote peace and understanding between various ethnic groups. The event also drew attention to business development along Anaheim Street.

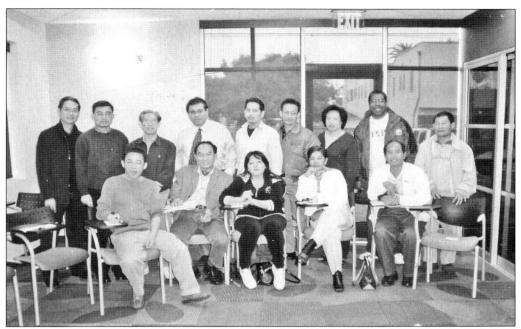

The first Cambodian New Year Parade meeting, held at the Union Bank offices on Long Beach Boulevard in 2004, included, from left to right, (first row) Pasin Chanou, Edward Tan, Sandy Cajas, Lok Srey Kem, and Chhay Yong; (second row) Phillip Thong, Sam Keo, Him Chhim, Victor Otiniano, Monorom Neth, Kim Suor Ngann, Rosana Chanou, Charles Brown, and Sereivuth Prak.

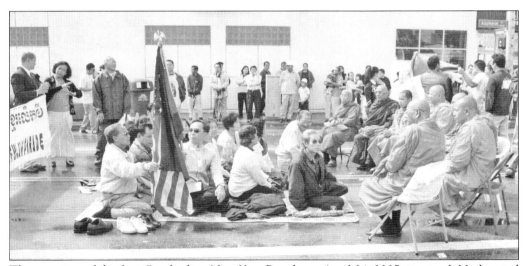

The morning of the first Cambodian New Year Parade on April 24, 2005, it rained. Undaunted by the weather, the monks gathered in the middle of Anaheim Street and began to chant to bless the event. By the time they were done, the clouds had given way to sunshine and blue skies.

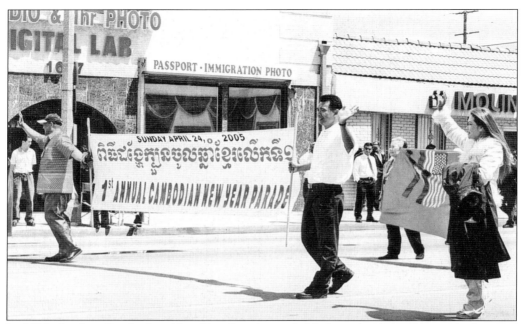

In 2005, the first Cambodian New Year Parade was held along Anaheim Street, the heart of the Cambodian community. The first parade marked the emergence of a stronger Cambodian community that had developed the political ties as well as the multigenerational and multiethnic coalition needed to mobilize a major event on the streets of Long Beach. Spearheaded by Cambodia Town, Inc., the parade has become a source of cultural pride for Cambodians and other ethnic groups.

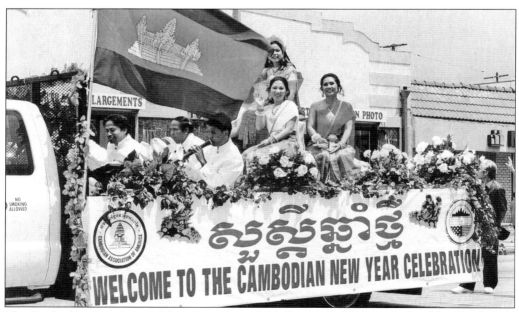

The Cambodian Association of America sponsored this float at the 2005 Cambodian New Year Parade to highlight the traditional dance and music programs offered through their organization.

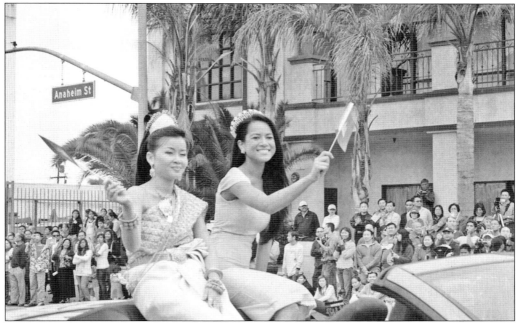

Soben Huon (right), who was crowned Miss Utah in 2006, appeared in the second Cambodian New Year Parade. She was born and raised in Long Beach, and her family still lives here. She moved to Utah to attend Brigham Young University.

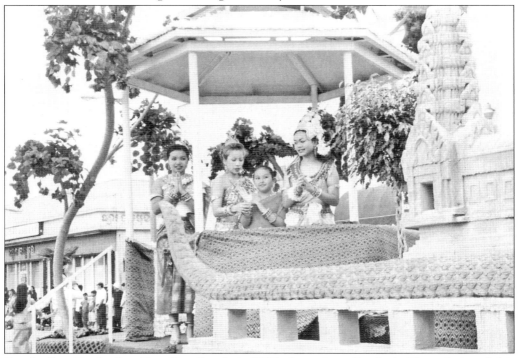

For the first Cambodian New Year Parade in 2005, the sculptor Sambath Chum designed this float, which is a replica of Angkor Wat.

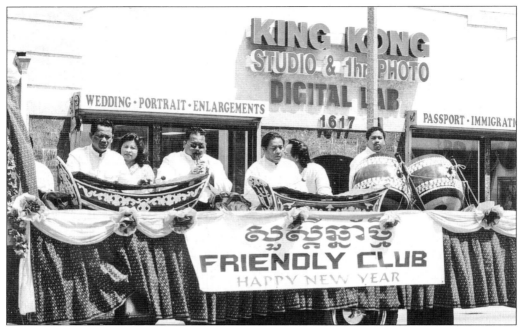

The Friendly Club is a Cambodian social club that was organized in 1991. The club focuses on building trust and friendship among Cambodian business owners. At the 2005 New Year Parade, the Friendly Club sponsored a float with a Cambodian musical ensemble led by Master Sambath Pich.

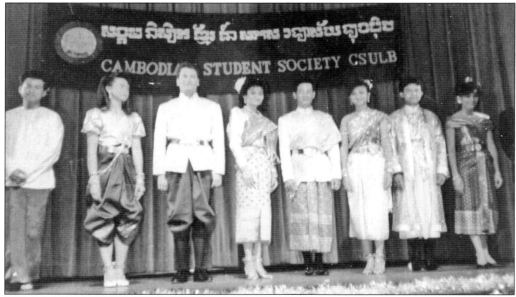

The Cambodian Student Society of California State University, Long Beach, holds an annual cultural show on campus to promote understanding and appreciation of their heritage. The event corresponds with Cambodian New Year events and has become a favorite community celebration. This picture was taken in 1987.

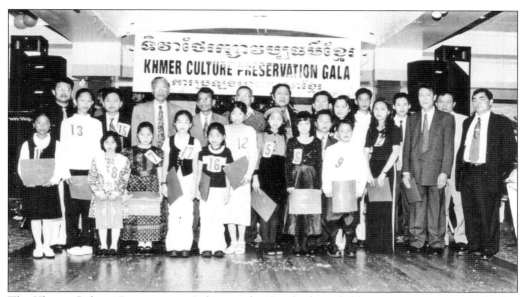

The Khmer Culture Preservation Gala provides Cambodian children an opportunity to display their knowledge of language and culture, and to compete for cash prizes. The gala is hosted and sponsored by community and business leaders as a way to promote the development and retention of the Khmer language and culture in Long Beach.

A new generation continues the tradition of promoting Khmer language and culture. Here Phylypo Tum of the Cambodian Humanitarian Organization for Peace on Earth, known as C-HOPE, hosts the spelling contest at the Khmer Language Gala. At these events, young Cambodians are introduced to key culture bearers and elders in the community, and meet young Cambodian professionals who can serve as role models.

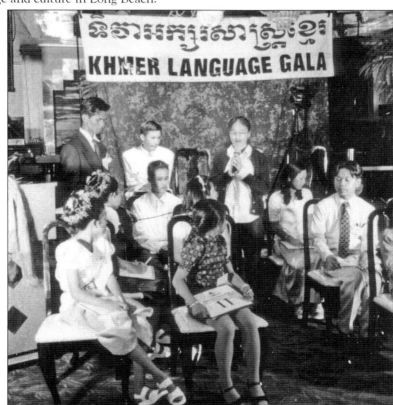

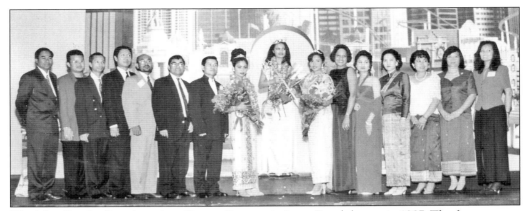

The Miss Cambodian-American Beauty Pageant in Long Beach began in 1987. The first pageant was organized by the United Cambodian Community, Inc.; the Cambodian Student Society of California State University, Long Beach; the Student Society of Long Beach City College; and the Cambodian National Conference. Then, in 1992 and 1993, the Cambodian Women and Families Association organized the event and received sponsorships from Cambodian businesses and individuals. As business owners prospered, beauty pageants became larger events. In 1998, the Miss Cambodian-American Beauty Pageant, presented by the Cambodian Business Association, was held at the Carpenter Center at California State University, Long Beach.

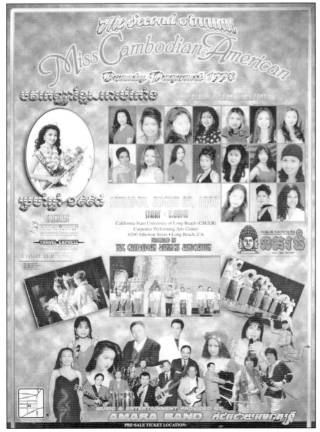

This is the advertising poster used to promote the 1998 Miss Cambodian-American Beauty Pageant. The poster illustrates a popular style of advertising in the community, and Cambodian businesses hang them in their shop windows.

Six

COMMUNITY ORGANIZATIONS AND GROUPS

Social networks are critical for refugees' adjustment to a new society. Long Beach became the place of choice for thousands of refugees throughout the 1980s and 1990s largely because of the concentration of Cambodian students, professionals, and evacuees who worked diligently to create a supportive social network. With funding initially from the Office of Refugee Resettlement (and later with government and foundation grants), two Cambodian mutual assistance associations were formed in Long Beach: the Cambodian Association of America (the oldest in the United States) and United Cambodian Community, Inc. These organizations became national models for the development and implementation of job training, literacy skills, health, and other social adjustment programs for refugees. Millions of dollars came into the city of Long Beach because of Cambodian leadership and the bilingual and bicultural staff working in these organizations, as well as in the school district, Los Angeles County, and the health department, just to name a few key institutions. It is important to note that federal refugee resettlement programs aimed to discourage Cambodians from moving to places like Long Beach for fear of overcrowding and the creation of an ethnic enclave that would hinder integration into American society. Over the last 30 years, the concentration of Cambodians in Long Beach has resulted in a flourishing community. Certainly, problems exist in the community. Social service programs are needed to address education, employment, health, and youth development needs, and to advocate on social and environmental justice concerns. Regardless of the social issues, however, most Cambodians believe that a key part of any solution entails promoting and retaining the Khmer culture.

This chapter does not represent all the activities of these organizations or all the groups that have been formed over the years in the Cambodian community. Rather the chapter provides a sampling of the activities of students, employees of different agencies, and cultural and social groups that have fostered their culture while providing critical services in the community.

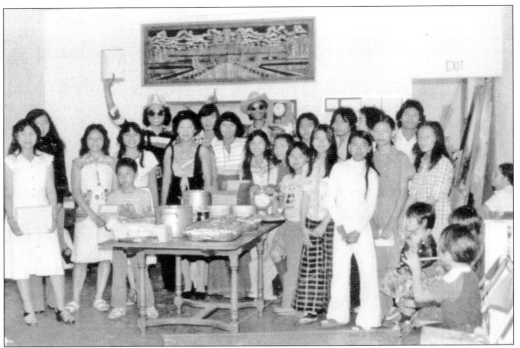

This photograph of the first group of volunteers to teach Khmer dance at the Cambodian Association of America (CAA) was taken around 1976. The CAA bases its programs on the social patterns of the Cambodian people with services provided like an extended family network. Many of the volunteers sponsored refugees who came to Long Beach.

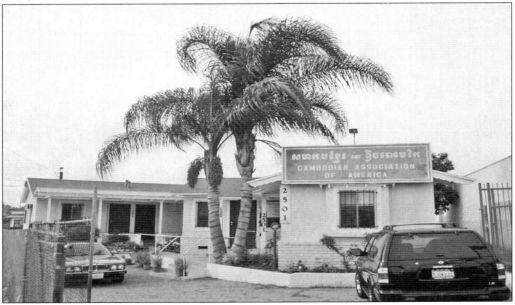

As programs expanded, the CAA opened an office at 2501 Atlantic Avenue in Long Beach. The building's façade illustrates how refugee programs were run like an extended family, and the staff and volunteers tried to create a warm atmosphere to help facilitate adaptation.

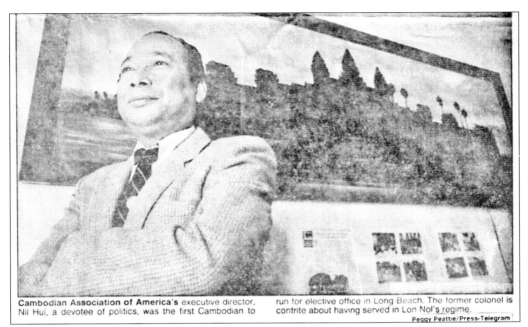

Cambodian community leadership developed in the social service agencies. Nil Hul, the executive director of the CAA in the early 1980s, was the first Cambodian to run for a Long Beach City Council seat in 1986, but he did not win. (Photograph by Peggy Pettie; courtesy *Press Telegram*, December 10, 1984.)

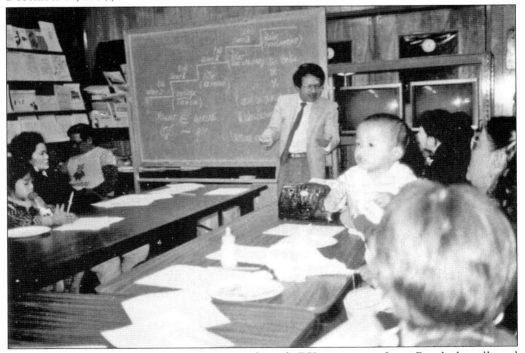

The Cambodian Association of America was the only ESL program in Long Beach that allowed parents to bring their children to the class.

UNITED CAMBODIAN COMMUNITY, INC.

(A NON-PROFIT ORGANIZATION)

សហគមន៍ខ្មែររួបរួម សូមជ្រើសរើស បុគ្គលិក ដូចតទៅ ដើម្បីបញ្ជើនសេវា ជនភៀសខ្លួន

១. អ្នកបើក រឿងការងារ / ទទួលសំណួរ ត្រើន (Intake Assessment Counselor)

២. រេខាធិការ ទោនាប់ភ្ញៀ .ទទួលសំណួរ ត្រើន (Intake Counselor/Receptionist)

៣. អ្នករុករស្វែង ផ្តល់ការងារ "កាត់កាលពេលវេលា" (Half-time job Developer)

៤. អ្នករុករស្វែង ផ្តល់ការងារ " រេញពេល " (Full-time job Developer)

៥. គ្រូបង្គាប់បណ្ដុះរៀនណែនាំទៅងារធ្វើមុនបានអ្នកការងារ (Pre-Employment Orientation Teacher)

៦. អ្នកបង្គាប់ បង្រៀន អំពីការឱ្យរាងអ្នកអនាមិក, (Instructors Janitorial, Gardening, Domestic skills)
 ការឃ្លាំឃើយ, រៀបបម្រើបំកិច្ចការផ្ទះសម្ងួន

៧. អ្នកបង្រឹងធមនុសអភិវឌ្ឍប្រទេស (Business Devoloper)

ការងារប្រចាំថ្ងៃទេងារពេរេន : នឹងផ្លូវរបស់ពេញ រួមតាម ការិយាល័យ ខីម្ងួ ។ ងារក្រូងាមទ:

១. ៧៨១០ ATLantic BLVD, LONG BEACH, CA.

២. Orange County Branch, SANTA ANA Area

៣. 11859 Rosecrans Ave. NORWALK, CA 90650

សូម របផ្តជួន ឯកសារ ស៊ើរតៅ ការិយាល័យ ធម រស NORWaLK.

ទូរស័ព្ទ:(213) 868 - 0706

The United Cambodian Community, Inc., (UCC) became the largest Cambodian social service agency in the late 1980s through the mid-1990s. This advertisement appeared in the Cambodian newspaper, *Nokor Thom*, on March 15, 1984. Community organizations like the UCC not only provided social services for the growing refugee population, they also offered jobs for Cambodians.

The United Cambodian Community, Inc., opened a vocational center in 1988. Programs at the vocational center included training in electronics and dental and medical assistant certification.

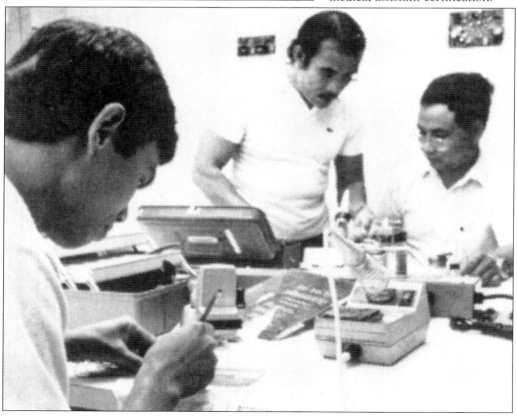

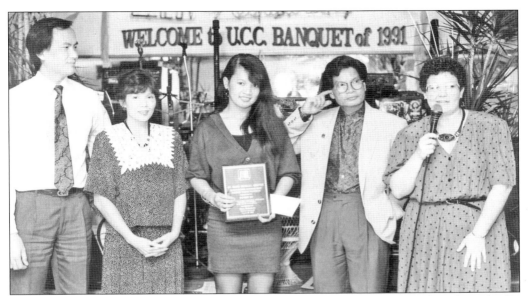

The UCC established a number of ties with larger institutions in Long Beach such as the St. Mary Medical Center. As a part of a city-wide jobs program, Cambodian youth were able to secure summer jobs that got them involved in community issues. At the UCC annual banquet in 1991, Sothy In received an award for her work at the St. Mary Medical Center. This photograph has many key directors involved in developing UCC programs. From left to right are Prany Sananikone, associate director; Lillian Lew, director of the Southeast Asian Health Project; Sothy In, award recipient; Than Pok, executive director; and Kayte Deioma, program assistant.

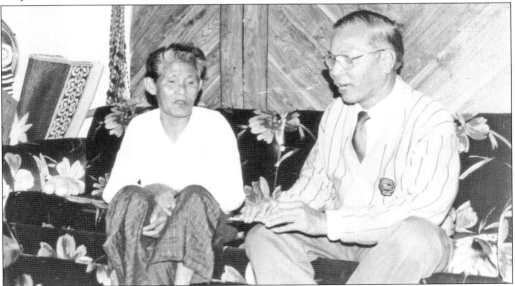

Men Riem, a community outreach worker, provides health education services to an elderly woman in her home. Many programs developed by the Southeast Asian Health Project, a venture between the UCC and the St. Mary Medical Center, were designed to reach out to the community rather than insist that the elderly come to an office. This social and cultural sensitivity to the needs of the community made programs like this successful.

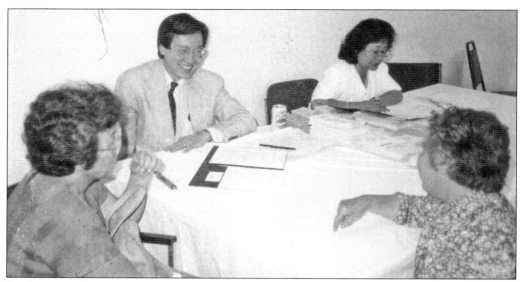

Dr. Song Tan (pictured on the left talking to two elderly Cambodians) had just finished medical school in Cambodia and was an intern at the hospital in Phnom Penh when the Khmer Rouge took control of the country. After he survived the "killing fields" of Cambodia, Dr. Tan continued his studies at the University of Hawaii and soon became a fellow of the American Academy of Pediatrics (FAAP). He has dedicated hours of volunteer service to the community. He is photographed at a health fair sponsored by the Southeast Asian Health Project at the UCC building in 1993.

Dr. Kosal Kom went to the University of Southern California Dental School. When he graduated from dental school, he set up a dental office inside the UCC building on Anaheim Street. This photograph was taken at the UCC around the time he finished dental school in 1993. He is providing dental health education to a young Cambodian girl. Dr. Kom continues to volunteer in community organizations and events.

Cambodian women have been critical in developing and providing social services to families in the community. They also educate the broader society about Cambodian culture and traditions through their activities. Dressed in traditional Khmer clothing at a St. Mary Medical Center health event in the early 1990s are, from left to right, Mony Chhom, Sophalla El Chap, Sisouat Ouk, Sinone Tuour, and Sadira Sokhan Dy.

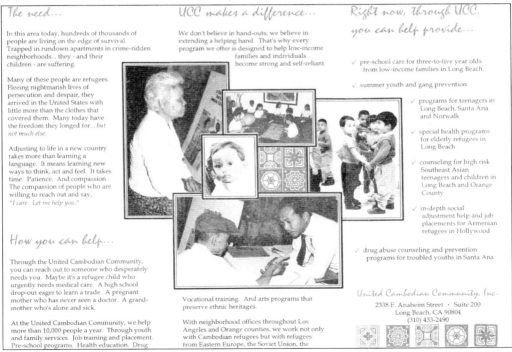

The need...

In this area today, hundreds of thousands of people are living on the edge of survival. Trapped in rundown apartments in crime-ridden neighborhoods... they - and their children - are suffering.

Many of these people are refugees. Fleeing nightmarish lives of persecution and despair, they arrived in the United States with little more than the clothes that covered them. Many today have the freedom they longed for... *but not much else.*

Adjusting to life in a new country takes more than learning a language. It means learning new ways to think, act and feel. It takes time. Patience. And compassion. The compassion of people who are willing to reach out and say, *"I care. Let me help you."*

How you can help...

Through the United Cambodian Community, you can reach out to someone who desperately needs you. Maybe it's a refugee child who urgently needs medical care. A high school drop-out eager to learn a trade. A pregnant mother who has never seen a doctor. A grandmother who's alone and sick.

At the United Cambodian Community, we help more than 10,000 people a year. Through youth and family services. Job training and placement. Pre-school programs. Health education. Drug

UCC makes a difference...

We don't believe in hand-outs; we believe in extending a helping hand. That's why every program we offer is designed to help low-income families and individuals become strong and self-reliant.

Vocational training. And arts programs that preserve ethnic heritages.

With neighborhood offices throughout Los Angeles and Orange counties, we work not only with Cambodian refugees but with refugees from Eastern Europe, the Soviet Union, the

Right now, through UCC, you can help provide...

✓ pre-school care for three-to-five year olds from low-income families in Long Beach.

✓ summer youth and gang prevention

✓ programs for teenagers in Long Beach, Santa Ana and Norwalk

✓ special health programs for elderly refugees in Long Beach

✓ counseling for high risk Southeast Asian teenagers and children in Long Beach and Orange County

✓ in-depth social adjustment help and job placements for Armenian refugees in Hollywood

✓ drug abuse counseling and prevention programs for troubled youths in Santa Ana

United Cambodian Community, Inc.
2338 E. Anaheim Street · Suite 200
Long Beach, CA 90804
(310) 433-2490

By the mid-1990s, the United Cambodian Community, Inc., had become a multi-million-dollar organization with programs serving Cambodians, other refugees, and the broader community.

The UCC Youth Scope program was a large, federally funded program to prevent substance abuse. The program offered an array of services for the entire family. Youth participated in theater arts and received academic tutoring and Khmer language and culture training. Long Beach mayor Beverly O'Neill (center) honors outstanding students in the program. (Courtesy of Kayte Deioma Photography.)

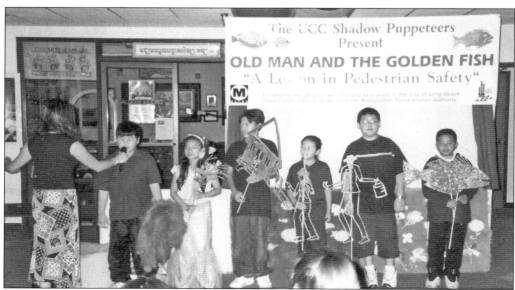

Social service programs often combine practical lessons with cultural education. At this UCC program, children learn about public safety through the traditional art of shadow puppetry.

Thira Srey (standing to the left of the poster), as a part of his role with the Cambodian Association of America, teaches a health class in the Cambodian Senior Nutrition Program at the California Recreation Center in Long Beach around 2003. The CAA helped to organize seniors and advocate for a program to address the nutritional needs of elderly Cambodians.

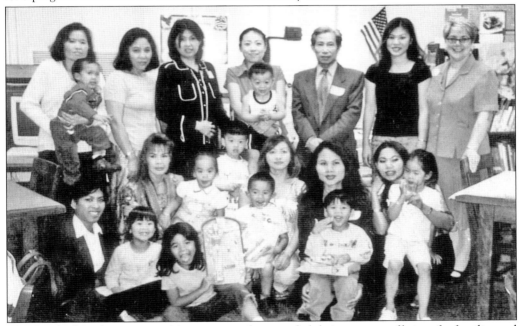

The Cambodian Association of America greatly expanded their program offerings for families and youth in the late 1990s. The CAA Family Literacy Program is an example of programs designed to promote educational opportunities. Him Chhim, the executive director of the CAA, is pictured with a group of women and their children.

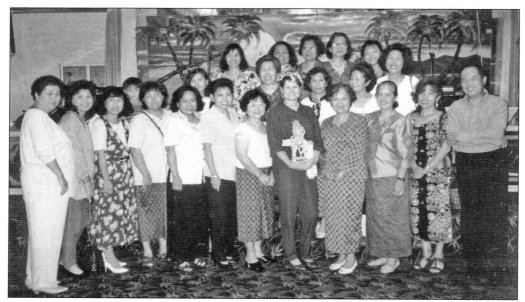

The Cambodian Women and Families Association is a group founded on the principles and practices of volunteerism that recognize the importance of focusing services on the entire family. It started off as a group of women dedicated to assisting Cambodians. In July 1993, the group received its nonprofit status and subsequently expanded their service to the community. This photograph was taken at the group's annual banquet around 1995.

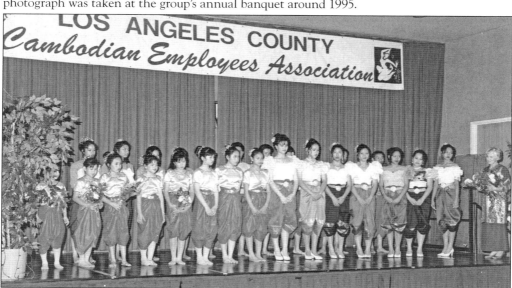

Cambodians represented a small percentage of the thousands of Southeast Asian refugees arriving in the United States during the 1980s. Most Americans assumed all Southeast Asians were Vietnamese, which meant that few programs addressed the specific needs of Cambodians. In 1988, several Cambodians working in the Los Angeles County Department of Public Social Services decided to form an association through which they could promote Khmer culture, values, and history. In 1989, they held their first Cambodian New Year banquet and culture show. A huge success, they have held the event every year since.

Samthoun "Sam" Chittapalo was the first Cambodian employee of the Long Beach Police Department, serving as a community liaison officer from the late 1980s to around 2001. He is pictured with some neighborhood children at an outreach event sponsored by the Neighborhood Services Bureau in the early 1990s.

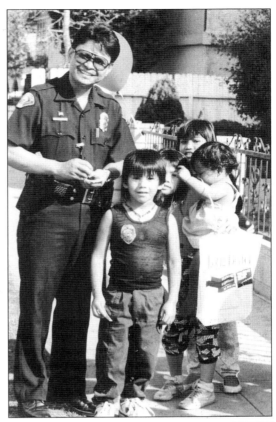

The Anaheim Street Community Police Center opened in October 1997 to address the public safety issues of families living in the Anaheim Corridor. Bryant Ben, as commissioner of the Public Safety Advisory Commission, assisted in establishing the center and continues to work as a community activist. (Photograph by Stephen Carr; courtesy *Press-Telegram*, December 7, 2001.)

Bryant Ben is a Cambodian community activist and field deputy for Councilwoman Laura Richardson-Batts. He also works part-time for the Anaheim Police Center, which recently moved to 1320 Gaviota Ave., assisting area residents, who are mostly Cambodian and Latino.

Stephen Carr / Press-Telegram

ABOUT CSS

What to look forward to...

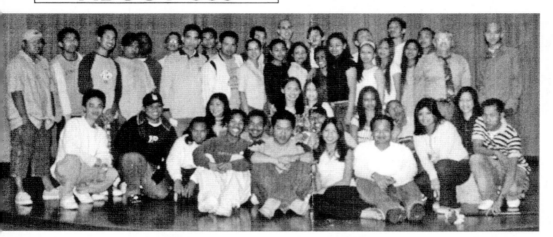

Since its first year of operation in 1984, CSS has established and continued to promote Cambodian heritage in America. It is one of the largest student organizations in United States with over 100 members.

The mission of the Cambodian Student Society at CSULB is to share, to promote, and to preserve Cambodian culture with the Associated Students of CSULB, by providing students with opportunities for association and interaction with the faculty and administration of CSULB and members of the community.

Guided by our mission, we pursue the following goals throughout our academic year:

- Address the particular concerns of the community.
- Support and strengthen alliances with other student organizations that seek to improve and promote Cambodian heritage in America.
- Recognize and encourage students who are working to increase the number of bachelor/ master degrees within their communities; and
- Assist in the preservation of Cambodian heritage through the Cambodian culture shows that promote wellness and enhance access to networking with other student organizations.

CSS Film Festival

Refugee, Who I Became

Remembering the Killing Fie
Fragile Hopes from the Kill
Fields, The Flute Player

20th Annual Culture Show

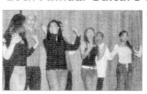

"The Spirit of Cambodia
"High school and
College students together."

Our Mission:

- To preserve Cambodian heritage
- To promote higher education
- To reach out to the community
- To unite Cambodian-Americans
- To build leadership skills

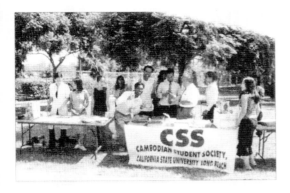

Family Orientation Day (FOD)

Another program CSS proudly holds every year is the FOD. This program is to educate first generation parents about the curriculums of the California State University Long Beach system. This is one step closer for parents to understand what their children will be going through the next years in their stage of higher learning.

On September 20th, 2003 the Cambodian Student Society and other cultural organization launched the sixth annual Family Orientation Day. Where Cambodian students and their parents attend for one day and receive information regarding financial aid, WPE, classroom expectations, curriculums, a tour of the university. Food, lunch, and entertainment including traditional Khmer dancing will be included.

Thank You ASI for your support!

Come and Join Us!

CSS THANKSGIVING DINNER

When?
Fridays, November 21, 2003
6:30 PM—11:30 PM

Where?
Soroptomist House

California State University, Long Beach, (CSULB) has the largest student group in the United States. In 2004, the CSULB Cambodian Student Society (CSS) celebrated its 20th anniversary. The CSS and other Cambodian student organizations continue the traditions of the Cambodian students who came to the Long Beach area in the 1960s and 1970s. These groups promote Cambodian heritage through culture shows and community activities. By providing mutual support and leadership opportunities, Cambodians have developed a network of professionals locally, nationally, and in Cambodia. This pamphlet illustrates the extent of student involvement at the university and in the Cambodian community.

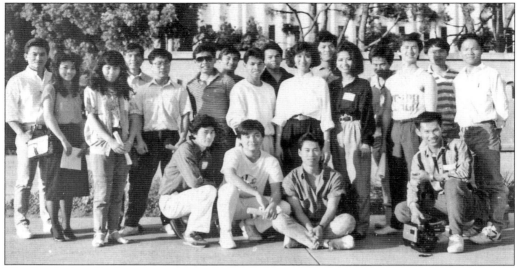

The Cambodian Student Association of Southern California, a group formed to address the needs of students at various universities, was founded in 1988. This picture was taken on the campus of California State University, Fullerton, in 1987.

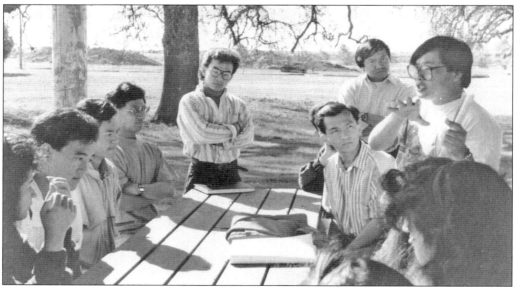

Students from CSULB also formed the United Cambodian Student Association (UCSA) in 1987. In the summer of 1992, a group of CSULB students went to Stockton, California, to assist other college students forming their own student groups. In this picture, Chanthan Chea (standing on the right), an advisor to UCSA, speaks to a group of students living and attending colleges in the Central Valley (Modesto, Fresno, and Stockton). Behind him is Henry Hora, the president of the UCSA. These outreach efforts helped to connect Cambodian students to a network of other students across the country and led to the establishment of a national UCSA conference.

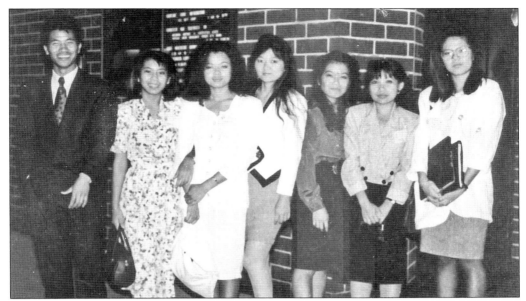

This picture was taken at a national UCSA conference in 1992. From left to right are Dey Mean, Leakena Nou, Kolvady Men, Ravy Chea, Sokkhun Kimpau, Manosothy Khean, and Christine Nou. Being a part of UCSA provided students with the needed social and emotional support to succeed in college. All the students pictured went on to be successful professionals. Noteworthy are the accomplishments of two of the students pictured, who have made their careers in Long Beach: Leakhena Nou is a professor of sociology at CSULB, and Kolvady Men operates a successful Cambodian boutique and wedding business.

The Cambodian American Club at Lakewood High School was founded in 1989. May Samoeun (far right) was the first Cambodian American teacher in the Long Beach Unified School District, and he taught Khmer language courses. Mory Ouk (far left) was a Khmer specialist for the Southeast Asian Language Project. Cambodian educators at various schools in Long Beach have been critical in helping students learn their language and culture.

A time of honor for Cambodians

High schools: Role models are praising graduating seniors.

By Elizabeth Chey
Staff writer

LONG BEACH – Just before lunch time, a group of 38 Cambodian high school seniors at Millikan High were ushered into the school cafeteria for a special presentation organized by leaders in the Cambodian community.

For many students, it was one of the few times their names were pronounced correctly when given an award. One of the few times they met with their community role models.

And for the first time, they were recognized for their academic achievements by their own community.

"You don't hear much about successful Cambodians and sometimes it limits you," said Voleak Rath, a senior who was given a plaque at the presentation. "There are few role models that we recognize in the community."

But getting students tapped into a support network and getting them involved in their own ethnic community is precisely the point, says organizer Terpsi Kapiniaris Tan.

"Like you, I'm a child of immigrants," said Tan, who is Greek-American, and married to

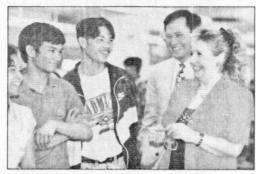

From left, Voleak Rath, Hong Sun and Bunthoeun Than talk with organizer Terpsi Kapiniaris Tan, right, and her husband, Dr. Song N. Tan, after receiving plaques for high achievement at Millikan High in Long Beach.
Suzette Van Bylevelt / Press-Telegram

culture – happy with being Cambodian – you'll also be a happy American."

The leaders are touring several Long Beach high schools over three days, and presenting plaques and words of encouragement to graduating Cambodians. They've collected money from businesses and community members to pay for the plaques and provide a few scholarships.

For the past six years, organizers have presented a huge banquet for the seniors. This year, they opted to tour the schools.

studies.

A total of 279 Cambodian high school seniors are scheduled to graduate from Long Beach schools this year – nearly 75 students more than last year's class. A number of them are distinguished scholars, including Millikan's valedictorian Bunthay Chorn.

"Our ancestors built Angkor Wat, so there's no limit to our success," said Him Chhim of the Cambodian Association of America. "And it's important to encourage the younger generation here in America to

Beginning in 1990, various organizations and individuals started the High School Graduation Award Ceremony as a way to inspire educational success among Cambodian youth. This newspaper article written by Elizabeth Chey, the first Cambodian journalist in Long Beach and a staff writer for the *Press-Telegram*, honors the organizing work of Dr. Terpsi Kapiniaris-Tan and Dr. Song Tan. (Photograph by Suzette Van Bylevett; courtesy *Press-Telegram*, June 10, 1997.)

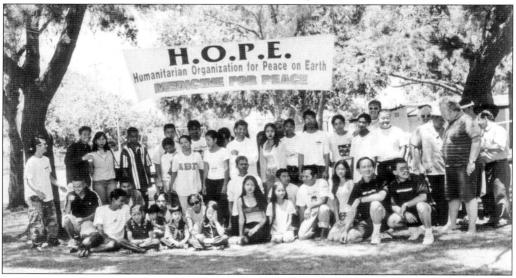

In 1997, a group of young college graduates decided to form C-HOPE, the Cambodian Humanitarian Organization for Peace on Earth. They did service projects such as sending medical supplies to Cambodia and college tours for Long Beach high school students. They are pictured here at Cherry Park before they added "Cambodian" to their name. Prany Sananikone (first row, second from right) was their advisor.

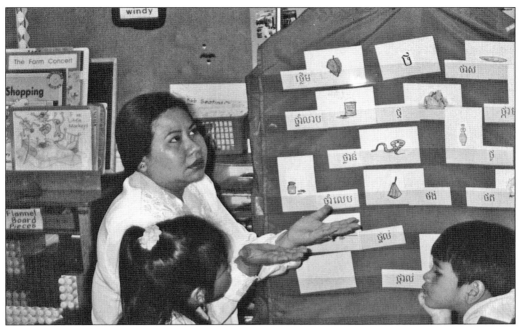

Before the passage of California's Proposition No. 227, which banned bilingual programs in schools, the Long Beach Unified School District developed Khmer bilingual programs at elementary schools with high populations of Cambodian students. Dual immersion programs still exist in the district but not at the same level as before. Model Meas, a teacher's aide, is seen here assisting students in a Khmer bilingual kindergarten class in 1997.

Kindergarten students and parents participate in a June 1996 graduation ceremony for the bilingual Khmer class taught by Wayne E. Wright at Abraham Lincoln Elementary School.

In 1997, a group of 14 Cambodian girls in Long Beach were part of a pilot project started by Asian Pacific Islanders for Reproductive Health to promote leadership skills. The pilot project has since grown into a self-sustaining Cambodian girl's leadership program called Khmer Girls in Action, which is dedicated to social justice issues. Twelve of the original members of this group, pictured here from left to right, are: (first row) Mary Im, Pisey Hour, Linda Lun, and Sophea Lun; (second row) Sothavy Meas and Vandavy Sea; (third row) Molica Pov-Meas, Monica Ching, Ra Pok, and Victoria Sim; (fourth row) Socheata Sun and Daneva Im.

The Southeast Asian Health Project, a joint venture between the United Cambodian Community, Inc., and the St. Mary Medical Center, received funding from the State of California to develop a teen pregnancy prevention program aimed at young men. A group of Cambodian teens (pictured on the poster) developed this program that they named Educated Men with Meaningful Messages (EM3). The program provides young men with opportunities for leadership and to serve as role models. This is the first poster the program developed as a way to reach out to other young men starting around 1996.

Seven

CIVIC ENGAGEMENT

Most people think of Cambodian refugees as survivors or even victims of political repression rather than active participants in American civic life. Cambodians in Long Beach, however, have been involved in national and local politics since their arrival. Initially, as depicted in chapter two, Cambodians were engaged in the democratic process because of the continuing political upheaval in Cambodia. Later involvement in the Republican Party was motivated by the need to advocate for democracy in Cambodia and to draw attention to the continuing plight of the Cambodian people. As the party in power and with a strong existing Asian community political network, the Republicans drew funds and support from the newly established Cambodian community. As the political situation in Cambodia began to change after the free elections in 1993, Cambodians began to turn greater attention to local issues and the need to strengthen Cambodian leadership in the city. Many Cambodian community leaders developed their knowledge of city politics and their relationships with other ethnic groups because of their work in social service agencies and business organizations. In essence, Cambodians built a strong base of networks with key local politicians and city officials they could draw upon for support and understanding.

The photographs and stories told in this chapter overlap with other chapters in this book. Part of rebuilding lives for Cambodians in Long Beach has been an integrated social, cultural, economic, and political process that cannot be easily separated. Therefore, the photographs in this chapter should be understood as a part of a 30-year journey that demanded sustained leadership and hard work on behalf of Cambodians both near and far.

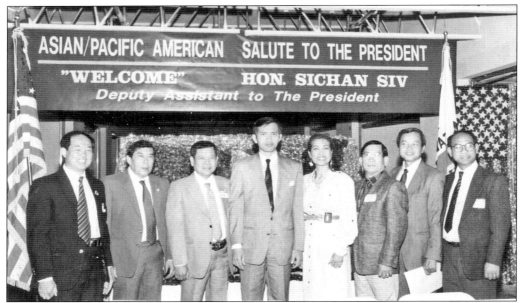

In 1989, then-president George H. W. Bush appointed Sichan Siv (pictured center), a Cambodian survivor of the "killing fields," as the first American of Asian ancestry to serve as deputy assistant to the president. His appointment boosted support for the Republican Party and helped to introduce Cambodians to national politics. The Honorable Sichan Siv met with members of the Long Beach Cambodian community at a Republican Party fund-raising event in 1991. From left to right are Ted Ngoy, Zanin Quouch, Norodom Vathmany, Sichan Siv, Sandy (San Arun) Blankenship, Ma Malapy, Sar Sithan, and Sakphan Keam.

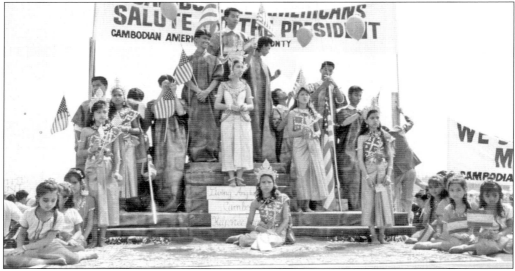

For the visit of Pres. George H. W. Bush, Long Beach Cambodian community members mobilized over 20,000 people to attend the Republican event at Mile Square Park in nearby Garden Grove. As a way to display the uniqueness of Khmer culture, the Cambodian delegation created a Living Angkor with people dressed in traditional clothing and wrapped in cloth to depict the stone towers of the famous Cambodian temple (pictured in the first chapter of the book).

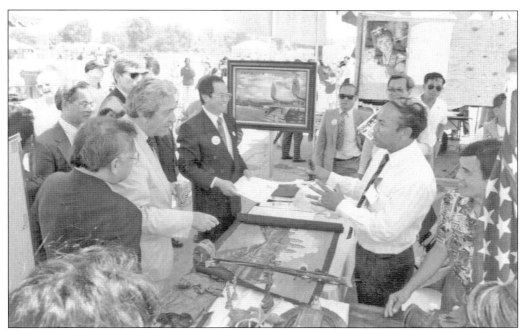

The Republican Party sponsored an event in May 1992 to commemorate Asian Heritage Month. A Cambodian delegation set up a booth to show the cultural heritage and contributions, and to educate politicians and other Asian leaders about the political situation in Cambodia. Sakphan Keam (right, center) is shown in this picture talking to Bruce Hutchinson (left, center), who was running for Congress at the time.

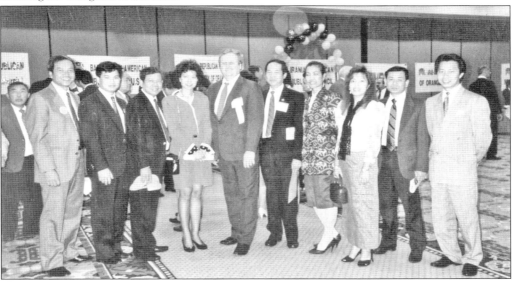

Participating in Republican Party events also gave local Cambodian leaders an opportunity to network with up-and-coming Asian activists such as Elaine Chao (who later become the secretary of labor under Pres. George W. Bush). Pictured from left to right are Sar Sithan, Richer San, Norodom Vathmany, Elaine Chao, Dennis Catron (chair of the Republican Committee in Orange County), Ted Ngoy, Sandy Blankenship, Christine Ngoy, Sahak Vaun, and Kenneth So.

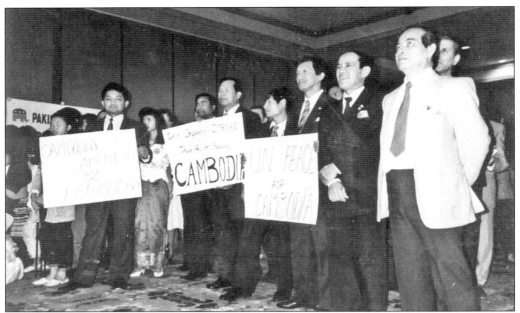

Before the first democratic elections were held in Cambodia in 1993, political activities included urging Republican leaders to support the United Nations' involvement in Cambodia. Long Beach community leaders are shown holding up signs expressing appreciation to the Republican Party and Congressman Bob Dornan for their support of free elections in Cambodia.

As Cambodians prospered in business, they hosted fund-raising events in their backyards for local Republican candidates. One successful businessman, Bun Tek "Ted" Ngoy, who made his fortune opening doughnut shops, sponsored political events in the 1990s at his mansion in Orange County.

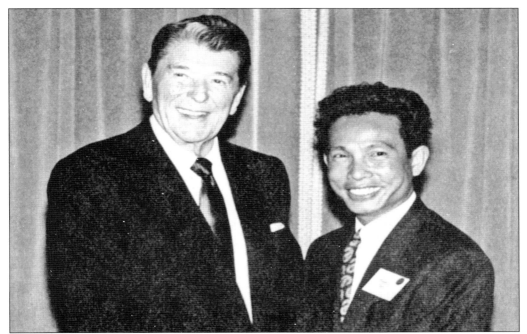

Cambodians were invited to top-level Republican fund-raisers because of their successful performance at other events. This fund-raiser held in 1991 in Beverly Hills shows Bryant Ben with Ronald Reagan.

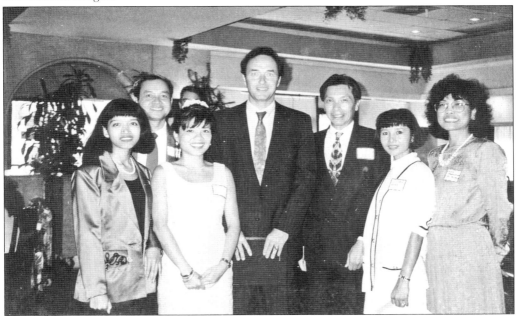

Cambodian community members organized a fund-raiser for Dan Lungren during his 1994 attorney general reelection campaign at Apsara Restaurant (now called La Lune). Pictured from left to right are Somaly Meas, Sar Sithan (behind Meas), Lok Srey Sibona, Dan Lungren, Vora Kanthoul, Sithea San, and Sandy (San Arun) Blankenship.

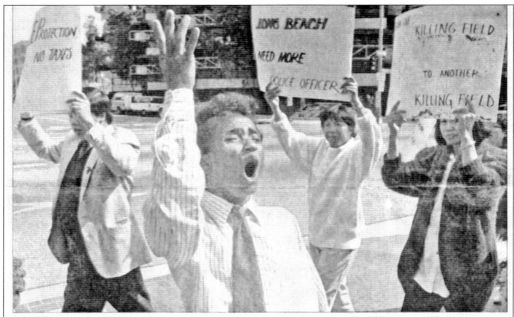

Chantara Nop leads a call Thursday at Long Beach City Hall for better police response to the needs of the Cambodian community, which has been plagued with killings, extortion demands and gang violence. Press-Telegram photos / Hal Wells

On April 19, 1991, members of the Cambodian community protested the increasing gang killings and extortion demands of Cambodian gangs, and they demanded more police protection. Cambodian businesses shut down for the day, thus decreasing tax revenue to the city and illustrating their growing economic clout. (Photograph by Hal Wells; courtesy *Press-Telegram*, April 19, 1991.)

Cambodian community leaders such as Sandy Blankenship, who was the director of the Cambodian Business Association, helped to raise money for local politicians. This is a photograph of a fundraising event for Bonnie Lowenthal when she ran for a place on the Long Beach Unified School Board in the 1990s.

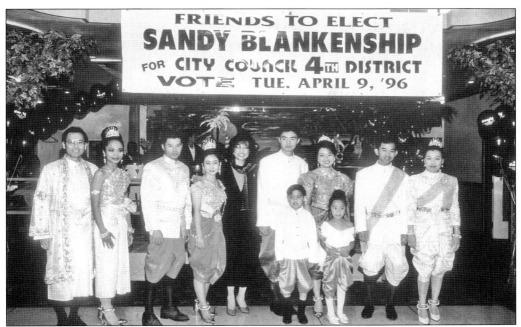

Sandy (San Arun) Blankenship (center) was one of the first Cambodians to run for public office in Long Beach. (Nil Hul, the executive director of Cambodian Association of America, had an earlier unsuccessful bid for a city council seat.) Although she was not elected, her foray into local politics marked a shift in focus among members of the Cambodian community from national politics to local leadership development. This picture was taken at a Long Beach Cambodian restaurant in 1996 with supporters dressed in traditional Khmer clothing.

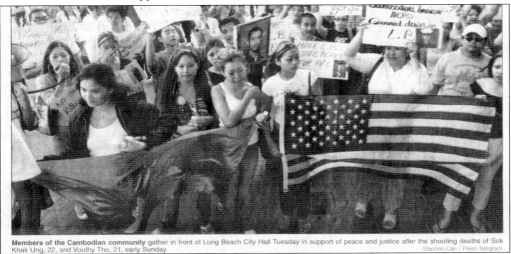

Members of the Cambodian community gather in front of Long Beach City Hall Tuesday in support of peace and justice after the shooting deaths of Sok Khak Ung, 22, and Vouthy Tho, 21, early Sunday.
Stephen Carr / Press-Telegram

On October 19, 2003, U.S. Marine Sok Khak Ung and his friend Vouthy Tho were gunned down in Long Beach. These murders—an apparent gang-style killing—reignited fears and concerns in the community about the need for the city to do more about youth violence and the continuing conflict between Latino and Cambodian gangs. In this photograph, which appeared in the Long Beach *Press-Telegram*, Cambodian community members march in front of city hall. (Photograph by Stephen Carr; courtesy *Press-Telegram*, October 22, 2003.)

A new generation of Cambodians are growing up proud of their culture and their American identity. Kolvady Men, who came to the United States as a child, became an American citizen on October 11, 1991. She proudly displays her certificate at the United Cambodian Community, Inc., offices, where she worked in the Summer Youth Employment Program.

First Cambodian American Citizenship Celebration, Long Beach, 1998

Federal policies toward refugees and immigrants were changing. Fears of being cut off from vital social services (such as Social Security insurance for the elderly and disabled, and welfare benefits) motivated Cambodian organizations to mobilize citizenship campaigns. The first Cambodian American Citizenship Celebration in Long Beach was held in 1998. Pictured from left to right are Sovanne Tith, unidentified, Loc Nam Nguyen, Congressman Stephen Horn, Him Chhim, and Michael Sieu.

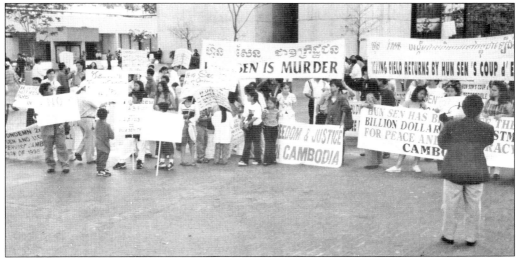

In 1993, the United Nations helped Cambodia hold its first democratic elections. The outcome left the country with two prime ministers sharing power—Prince Norodom Ranariddh, a member of Cambodia's royal family, and Hun Sen, head of the Cambodian People's Party (CPP). On July 7, 1997, Hun Sen overthrew Ranariddh in a violent coup. Greatly alarmed and fearing a return of the "killing fields," members of the Cambodian community gathered at Long Beach City Hall to let the world know their concerns.

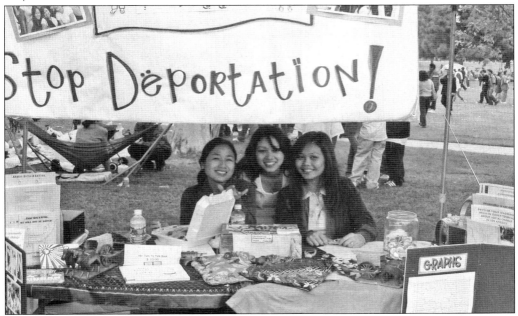

In 2002, the United States and Cambodia reached a diplomatic agreement allowing the deportation of Cambodian nationals even if they came to the United States as refugee children. The Khmer Girls in Action (KGA), a girl's leadership program in Long Beach, helped to mobilize public attention regarding the deportation of Cambodians suspected of gang-related crimes. KGA set up a booth at the Cambodian New Year Festival in 2004. Pictured from left to right are Que Dang, Sophya Chum, and Meeta San.

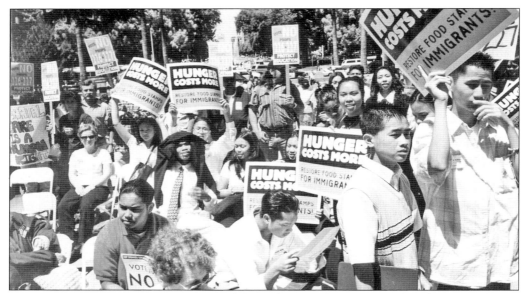

In 1998, anti-immigrant sentiment in California became fierce as federal and state legislation took aim at immigrant rights. The Khmer Girls in Action (KGA) mobilized Cambodian youth in a Los Angeles protest against the federal welfare reform act (passed in 1997), which eliminated refugee and immigrant access to food stamps and other public assistance. Due to events like the one shown here, California legislators restored some of these benefits to refugee and immigrant residents of the state. However, California Proposition No. 227, which banned bilingual education, passed in 1998 despite the efforts of activists.

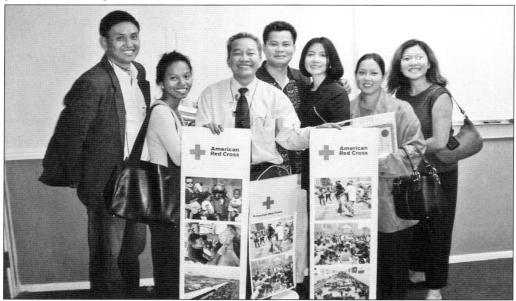

Moved by the tragedy of Hurricane Katrina, a group of Cambodians came together to raise money for the American Red Cross. The event they sponsored in MacArthur Park on Anaheim Street raised more than $20,000. Pictured from left to right are Peter Long, Sophois Sokhom, Sweety Chap, Richer San, Sithea San, Socheata Chap, and Sophonna Nong.

Eight

BUSINESS DEVELOPMENT AND ANAHEIM STREET

Cambodians have settled throughout Long Beach and the surrounding cities. The heart of the community is located along Anaheim Street between Atlantic and Junipero Avenues. This is the largest concentration of Cambodian residences and businesses in the city. The first businesses were located on Tenth Street, one block south of Anaheim Street, but Anaheim had more business buildings and a wider street, making new business development easier. In 1975, when Cambodians began settling in this area, it was economically depressed and a high crime area. It has slowly been rejuvenated as Cambodians have opened shops and purchased and developed property. Businesses opened included auto repair shops, Cambodian groceries and restaurants, tailors, travel agents, jewelry stores, beauty salons, photograph and video stores, and, of course, doughnut shops.

The Cambodian section of Long Beach has had different unofficial names throughout the years. The city of Long Beach has long been nicknamed "Iowa by the Sea" because of the high number of Midwesterners who migrated here in the late 1800s. In a play on that name, newspapers began referring to the Cambodian community as "Phnom Penh by the Sea" shortly after Cambodians began settling here. It has also been called "Little Phnom Penh" and "New Phnom Penh." In 2001, the Cambodia Town Initiative Task Force, led by Harrison Lee, submitted a proposal to the City of Long Beach requesting that a section of Anaheim Street between Atlantic and Junipero Avenues be officially designated "Cambodia Town." The name was selected by the group, in part, because it is more recognizable to mainstream Americans than Phnom Penh is. After many setbacks, Cambodia Town finally received official recognition from the city on July 3, 2007.

The photographs in this chapter present some of the major events and organizations in Cambodian business development and are not intended to provide an exhaustive listing of the estimated 300 Cambodian businesses in the city of Long Beach.

In 2001, pink banners were placed along Anaheim Street by the United Cambodian Community, Inc., identifying the area as "Little Phnom Penh."

This map shows what is considered the "heart" of the Cambodian community along Anaheim Street.

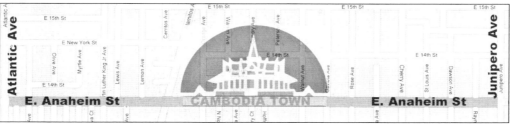

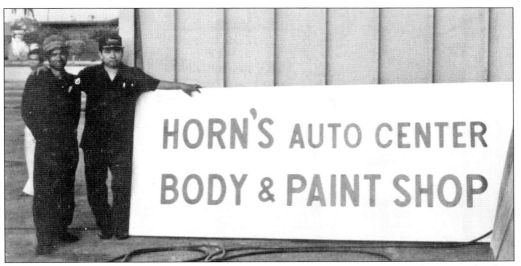

Most Cambodians arriving in 1975 had training in engineering or agriculture, so the first businesses they opened were automotive. Krithny Horn opened Horn's Auto at Anaheim Street and Atlantic Avenue in 1980. Horn's Auto was among the first Cambodian businesses in Long Beach. Below, Horn also trained other Cambodians in auto mechanics.

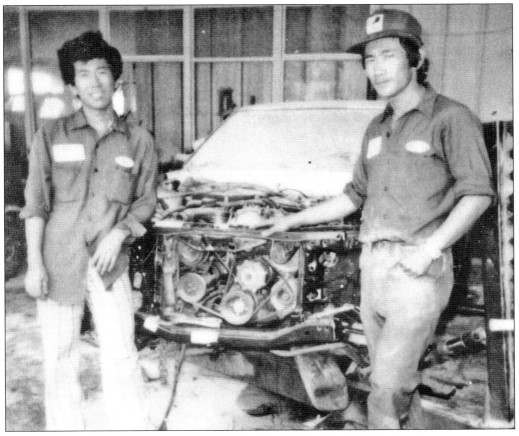

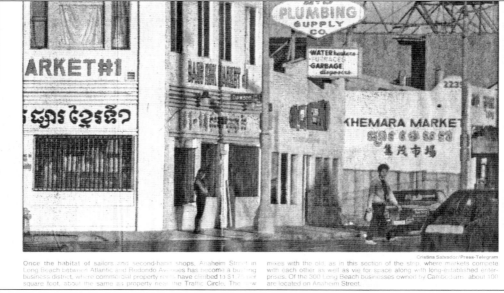

Once the habitat of sailors and second-hand shops, Anaheim Street in Long Beach between Atlantic and Redondo Avenues has become a bustling business district, where commercial property rents have climbed to $1.75 per square foot, about the same as a property near the Traffic Circle. The new mixes with the old, as in this section of the strip, where markets compete with each other as well as vie for space along with long-established enterprises. Of the 300 Long Beach businesses owned by Cambodians, about 100 are located on Anaheim Street.

A 1989 *Press-Telegram* article discusses Cambodian businesses along Anaheim Street. Anaheim Street was a rundown "slum" and a dangerous area when Cambodians began settling here. Many stores were empty and boarded up. No one living in the area would walk on the streets at night. As this article reports, the Cambodians had a positive impact on the street, opening many shops, most of which served the growing community. (Photograph by Cristina Salvador; courtesy *Press-Telegram*, December 11, 1989.)

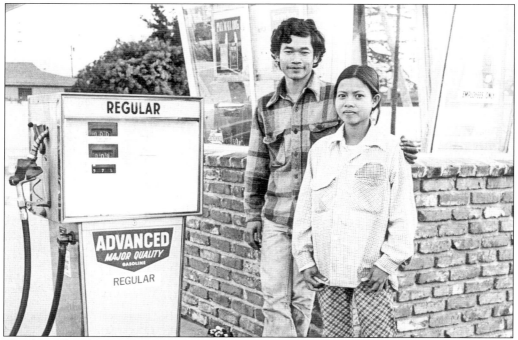

The first jobs Chay Yim (left) and Rina Uch had were at a gas station in West Long Beach on the corner of Santa Fe Avenue and Wardlow Road.

The dancer Leng Hang received a beautician's license in 1977 shortly after arriving in the United States. Her salon on Long Beach Boulevard was large enough for her to style hair, teach Cambodian classical dance, make costumes for dances and weddings, and provide space for weavers.

One of the most often heard reasons why Cambodians moved to Long Beach was to get the kinds of food they were used to. Bayon Market, named after the 13th-century Khmer temple mentioned in chapter one, was one of the earliest markets on Tenth Street that catered specifically to Cambodian tastes.

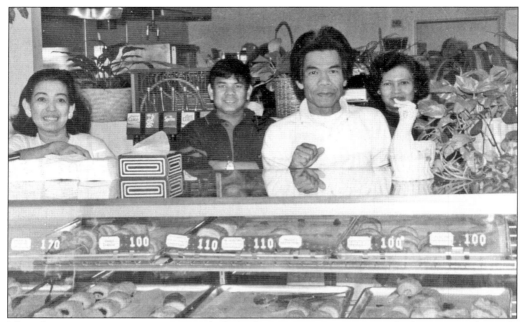

Most American immigrant stories include finding success in one particular business niche with which the group becomes identified. For Cambodians, it has been doughnut shops. These kinds of small businesses worked well for the Cambodians because they could be run by families and did not require extensive English language skills. Pictured is Rothary Dimang (at the counter) at his shop on Pine Avenue and Fourth Street, which he ran between 1983 and 1985. To the left is Simone, his wife. Behind him are other family members who helped in the shop. Lu Lay Sreng opened the first Cambodian doughnut shop, Daisy Doughnut, in nearby Lakewood in 1975.

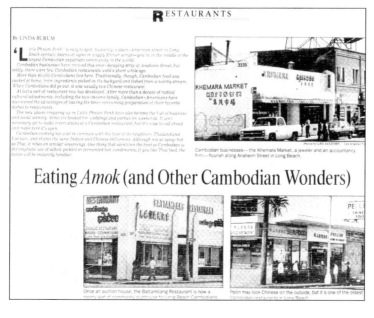

In 1990, the *Los Angeles Times* ran a feature article on Cambodian restaurants in Long Beach. Pictured here are smaller restaurants. The larger restaurants, such as La Lune on Atlantic Avenue, and New Paradise, and Hak Heang, both on Anaheim Street, are booked every weekend of the year for special events, including weddings, graduation parties, and organization anniversaries and fund-raisers. (Photographs by Leo Jarzomb; courtesy *Los Angeles Times*, May 13, 1990.)

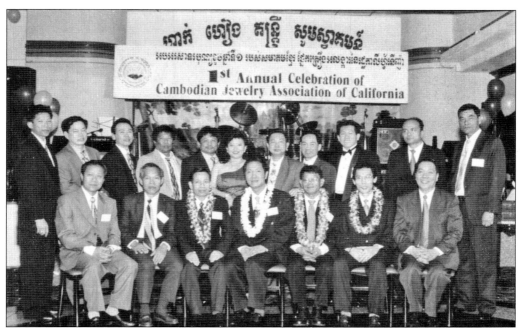

The board of directors and advisors of the Cambodian Jewelry Association of California gathered for a photograph commemorating their first anniversary in 1999. The art of jewelry making was not written in books in Cambodia. Instead it was transmitted orally to family members and apprentices. One of the major contributions of the Cambodian Jewelry Association was to publish *Jewelry Skills and Techniques*, a practical book on all aspects of gemstones and precious metals. At the time of its publication, there were some 17 Cambodian jewelry stores located in Long Beach.

Over the years, local politicians and city departments have recognized the importance of Cambodian business leadership in bringing together multi-ethnic coalitions essential for the planning and implementation of successful events on Anaheim Street. In this photograph, Long Beach mayor Beverly O'Neille (right) presents Sandy (San Arun) Blankenship, the executive director of the Cambodian Business Association, a city proclamation commemorating the Anaheim Street International Festival on October 2, 1993.

Pictured above is the groundbreaking ceremony for the United Cambodian Community, Inc., (UCC) Building in 1991. Pictured from left to right are Mayor Ernie Kell; Dean Dana, Los Angeles County supervisor, fourth district; Tom Clark, councilmember and former mayor, fourth district; Than Pok, UCC executive director; Clarence Smith, councilmember, sixth district; Evan Braude, councilmember, first district; and Stephen Lesser, UCC chairman of the board. Below, the completed UCC Building is home to several Cambodian businesses and is available for community uses. As the first major building project in the community, it has been an important landmark and symbol of the community's growth.

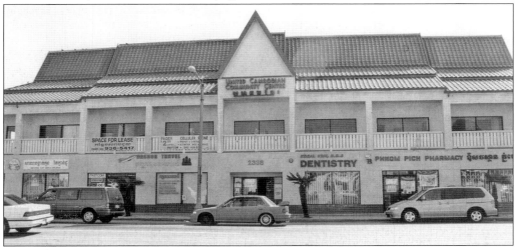

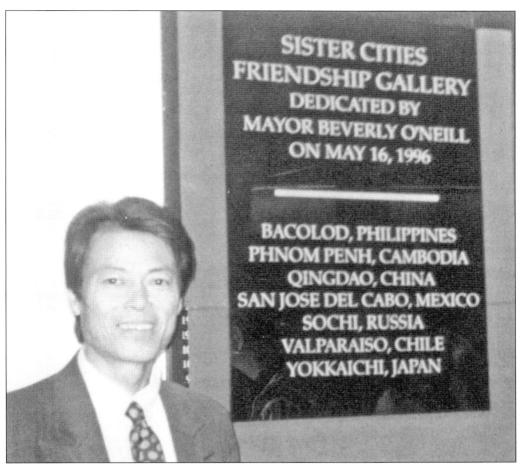

The cities of Long Beach and Phnom Penh became sister cities in 1994. Their mission is "to promote and expand effective and mutually beneficial cooperation between the people of Long Beach and the people of Phnom Penh." Pictured here is Thommy Nou, who served as the chair of the Long Beach/Phnom Penh Sister Cities after Sandy Blankenship, who was the first chairperson. One of the first projects undertaken by the Long Beach/Phnom Penh Sister Cities was to send a fire truck, donated by the City of Long Beach, to Cambodia (below).

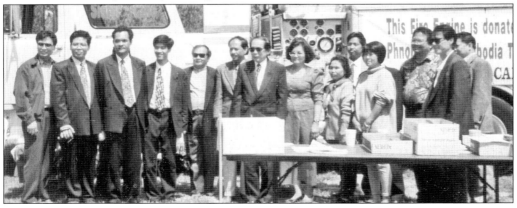

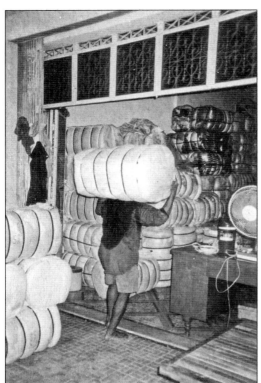

After Cambodia reopened in the early 1990s, Cambodian Americans began building economic links with the homeland. Many products have been exchanged between the countries. Activities include importing Cambodian rice and video production and sales. In 1993, a group packaged and shipped bales of used clothes to Cambodia for their markets there.

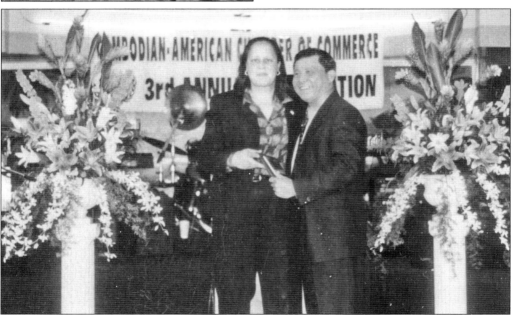

The Cambodian American Chamber of Commerce was formed to promote the networking of area businesses and to enrich the understanding of Cambodian economics, culture, and education. Shown here is Phana Tap presenting sixth district Long Beach City Council member Laura Richardson with an award in 2002.

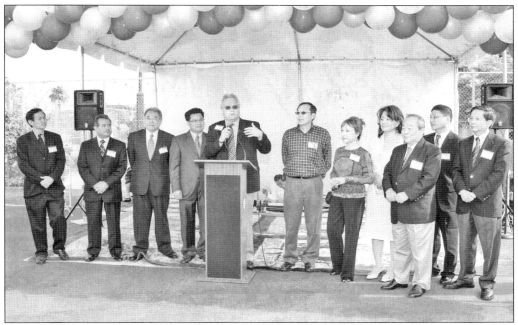

The first Cambodian-run bank in the United States opened in Long Beach on June 5, 2007. Pictured from left to right are the board of directors: Peter Long, Jaxier Aguilera, William Lu, Richer San, Evan Braude, Kern Kwong, Christina Wong, unidentified, Dr. Caleb Zia, Dr. Arthur Lu, and Rowland Jones.

Founding members of the Cambodia Town Initiative Task Force, formed by Harrison Lee in 2001, are (from left to right) Pasin Chanou; Rosana Chanou; David Kar; Solange Kea, Esq.; Annie Lee; Harrison Lee; Dr. Morokod Lim; Kenneth So; Philip Thong; and Sovuthy Tith.

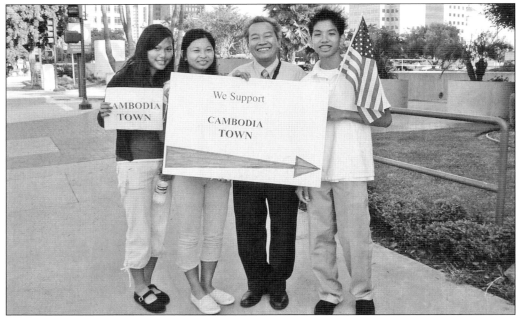

Sweety Chap (third from left) and student volunteers were among many who directed traffic to the October 24, 2006, meeting of the Long Beach City Council. The community fully expected the council to approve the designation of "Cambodia Town" that night, but it was bitterly disappointed when the request was referred to the housing and neighborhood sub-committee for further review.

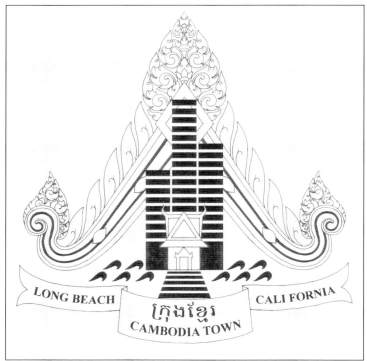

On July 3, 2007, six years after it was first proposed, "Cambodia Town" was officially designated by the Long Beach City Council. Pictured here is the official logo of Cambodia Town, Inc.

Nine

SPORTS AND RECREATION

Sports and other recreational activities are a way to build friendship and trust, and to develop physical skills and mental endurance. Through the efforts of individuals and community organizations, several sports groups and recreational opportunities have been developed in Long Beach. In most instances, these activities purposely attract other Cambodians. Some may think this isolates Cambodians from mainstream society and illustrates a lack of integration. For a refugee population and a new generation growing up as Cambodian American, however, the camaraderie built through competitive sports and recreational activities has helped them build confidence and social networks that can be drawn upon as they advance in society.

For older Cambodians, recreational opportunities keep them healthy and tethered to others in the community. This chapter depicts some of the sports and recreational groups formed over the years and the community members who have worked hard to develop these programs.

Soccer was the national sport of Cambodia. The first Cambodian soccer league was established in Long Beach in 1984 by Bryant Sokphanarith Ben (second row, seventh from left). The team traveled to other locations to encourage the development of Cambodian teams. This 1985 picture was taken at a tournament in Fresno, California. Bryant Ben has contributed to the organization of several sports programs in the Long Beach area.

Cheng Heng, a former head of state in Cambodia from 1970 to 1972, started the first Cambodian Boy Scout den in Long Beach.

Aumry Ban (left) was a national kickboxing champion in Cambodia who came to the United States as a refugee in 1981. He eventually moved to Long Beach in 1986, and a year later, Ban opened the Khmer Kickboxing Center on Anaheim Street. He spends countless hours training young men—Cambodian and non-Cambodian—in the traditional art of kickboxing. Many of Ban's students have won kickboxing titles. Ban is pictured here with one of his successful students, Mamarong May.

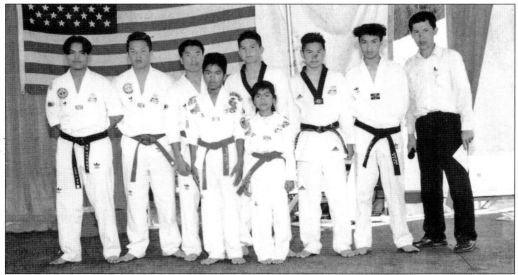

Many Cambodian youth are drawn to the discipline provided by training in tae kwon do. In this photograph, Lok Kruu Sam and his students demonstrate their skills at the Cambodian New Year festival in 1999.

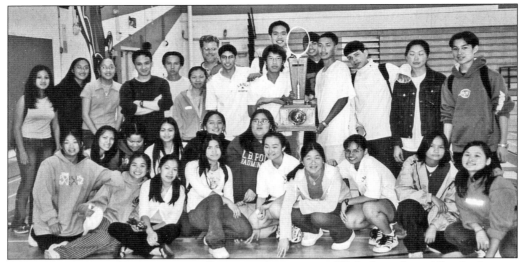

Badminton is a popular sport, especially among Asian groups. With the influx of Cambodians to Long Beach, interest in badminton grew, resulting in the first coed team in the school district, which started in 1987. This photograph of the Polytechnic High School badminton team, coached by Steve Meckna, was taken at the finals of the Moore League Championship in 2002. More than half the team is Cambodian.

Sokneath Prak played badminton at Polytechnic High School and has been the junior varsity coach at Wilson and Polytechnic High Schools. Holding the Polytechnic High School badminton team's Moore League Championship Cup in 2003 are (from left to right) Siumui Chia, Fritz Gochuico, Sokneath Prak, and Nicholas Jinadasa.

Generally not considered a Cambodian sport, tennis has grown more popular in the Cambodian community because of the annual Khmer Greater Long Beach Tennis Tournament, which was founded in 1997 by Saren Sok, Brian J. Vikram, and Bill R. Chhay. This picture taken at the 1998 tournament shows the doubles first-place winners, Rath Sakhem (left) and Saren Sok.

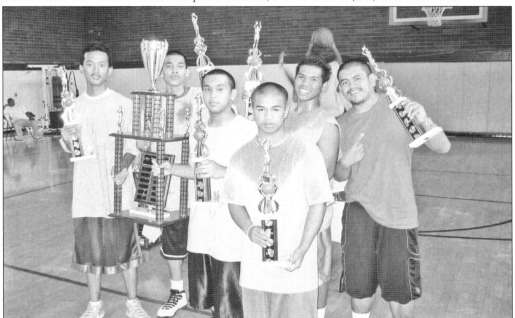

As a way to promote boys' leadership development, the community program EM3 started an annual basketball tournament in 1998. Teams from throughout the city compete. In this 2006 photograph taken at the Boys and Girls Club of Long Beach, Petrolane Center, members of EM3's high school league team show off their championship trophies. Pictured from left to right are Jesse Chhing, Ricky Po, Roger Dim, Shawn Samreth, Dennis Nam, and coach Sovanna Has.

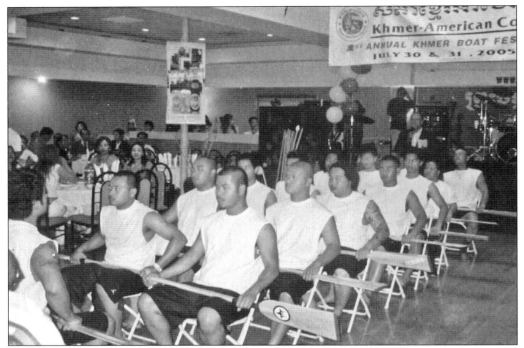

Sports teams are supported by Cambodian organizations and businesses. The Long Beach Nagas Cambodian dragon boat team members demonstrate their paddling skills at the First Annual Khmer-American Council banquet in 2005 as a way to drum up interest in and support for their activities.

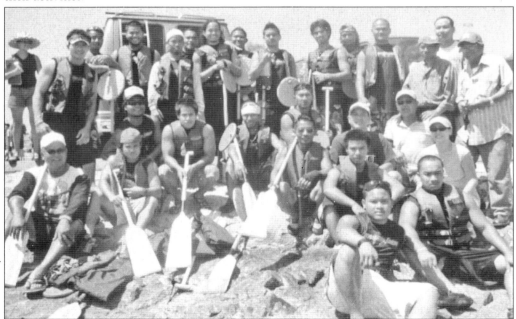

The Long Beach Nagas Cambodian dragon boat racers are pictured at the 2005 Water Festival in Long Beach.

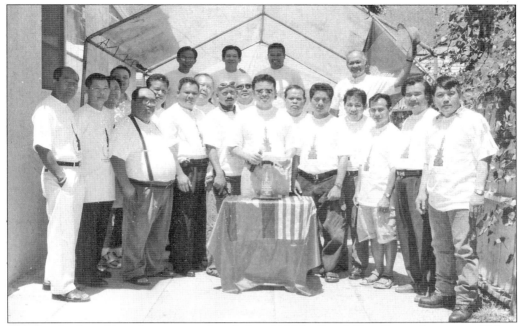

The Cambodian Chess League was founded in 2000 by Frank You (better known as Chhan Chhour), who is standing in the center of the group behind the trophy. Although a relatively new group in Long Beach, it is the first all-Cambodian chess league. Interest in the group has even spread to Cambodia. This picture was taken at a 2006 tournament.

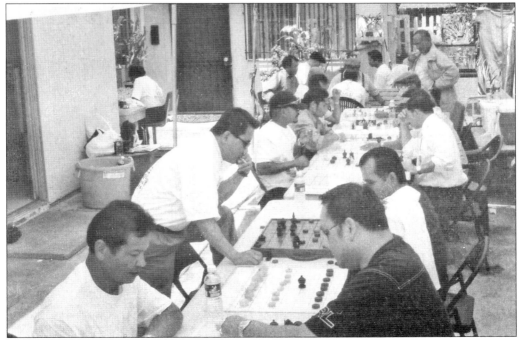

In this 2006 photograph, members of the Cambodian Chess League conduct tournaments in a backyard. These events aim to promote competition and to foster friendship.

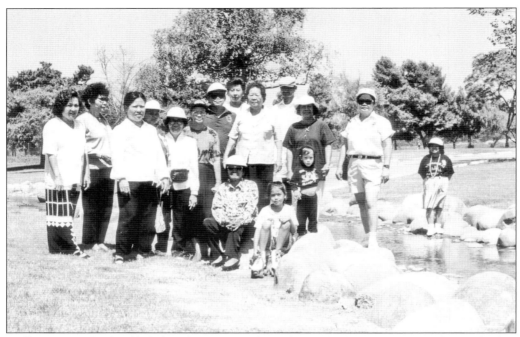

Walking groups for the elderly have become popular in the Cambodian community. The Cambodian Association of America, among other programs, has helped to facilitate the development of these healthy activities.

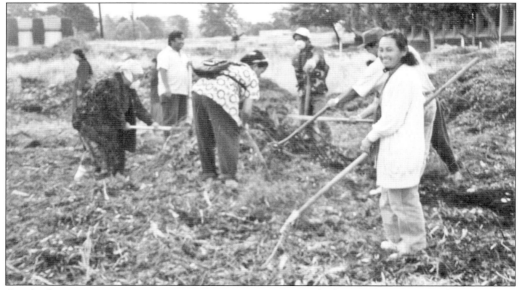

Cambodian community organizations, in conjunction with the city of Long Beach and Signal Hill, have provided gardens on public land for use by Cambodians and other Southeast Asians since the 1990s. Since many Cambodians live in apartment complexes, they do not have adequate land on which to garden as they once did in Cambodia. These gardens provide not only access to more nutritious foods, they also provide a space for community members to socialize and build a sense of belonging.

SELECTED READING

Chan, Sucheng. *Not Just Victims*. Chicago: University of Illinois Press, 2003.

Chandler, David. *A History of Cambodia*. Boulder, CO: Westview Press, 1992.

Ebihara, May, Carol Mortland, and Judy Ledgerwood. *Cambodian Culture Since 1975: Homeland and Exile*. Ithaca, NY: Cornell University Press, 1994.

Etcheson, Craig. *After the Killing Fields: Lessons from the Cambodian Genocide*. New York: Praeger Publishers, 2005.

Higham, Charles. *The Civilization of Angkor*. Berkeley, CA: University of California Press, 2004.

Kiernan, Ben. *The Pol Pot Regime: Race, Power, and Genocide in Cambodia under the Khmer Rouge 1975–1979*. New Haven, CT: Yale University Press, 1996.

Needham, Susan and Karen Quintiliani. "Cambodians in Long Beach, California: The Making of a Community." Journal of Immigrant and Refugee Studies. 5(1) 2007, pp. 29–53.

Phim, Toni Shapiro and Ashley Thompson. *Dance in Cambodia*. New York: Oxford University Press, 2001.

Smith-Hefner, Nancy. *Khmer American: Identity and Moral Education in a Diasporic Community*. Berkeley, CA: University of California Press, 1999.

SELECTED NARRATIVES

Him, Chanrithy. *When Broken Glass Floats*. New York: W. W. Norton and Company, 2001.

Lafreniere, Bree. *Music Through the Dark*. Honolulu, HI: University of Hawaii Press, 2000.

Phim, Navy. *Reflections of a Khmer Soul*. Tucson, AZ: Wheatmark, 2007.

Pran, Dith. *Children of the Killing Fields*. New Haven, CT: Yale University Press, 1999.

Schanberg, Sydney. *The Death and Life of Dith Pran*. New York: Penguin Press, 2007.

Szymusiak, Molyda. *The Stones Cry Out*. New York: Hill and Wang, 1986.

Vitandham, Oni. *On the Wings of a White Horse*. Mustang, OK: Tate Publishing, LLC, 2005.

ACROSS AMERICA, PEOPLE ARE DISCOVERING SOMETHING WONDERFUL. *THEIR HERITAGE.*

Arcadia Publishing is the leading local history publisher in the United States. With more than 4,000 titles in print and hundreds of new titles released every year, Arcadia has extensive specialized experience chronicling the history of communities and celebrating America's hidden stories, bringing to life the people, places, and events from the past. To discover the history of other communities across the nation, please visit:

www.arcadiapublishing.com

Customized search tools allow you to find regional history books about the town where you grew up, the cities where your friends and family live, the town where your parents met, or even that retirement spot you've been dreaming about.